Photography Demystified

Your Guide to the World of Travel Photography

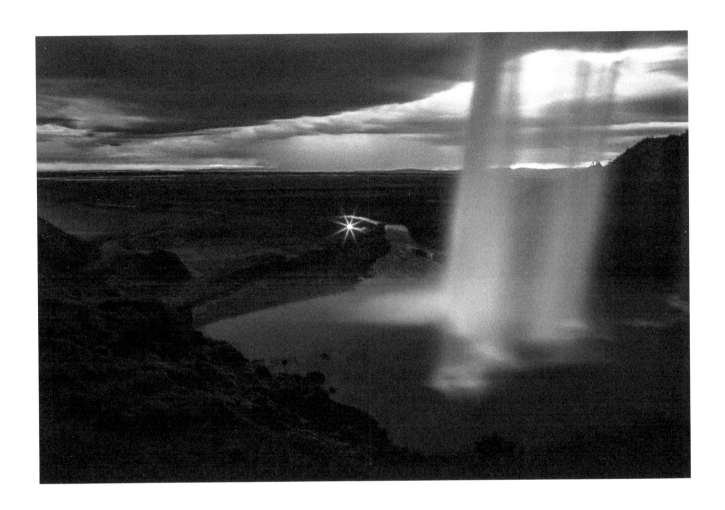

How to Explore, "See," and Photograph the World!

David McKay

As a thank you for purchasing my book, please click here to gain **UNLIMITED FREE** access to many photographic educational videos!

http://mckaylive.com/bonus

Unless noted, all images by Author David McKay
www.mckaylive.com/books

For orders, please email: mckaylive@yahoo.com

ISBN: 978-1-68419-911-2

For the Traveler Who Loves to Photograph

This book is dedicated to all those who suffer from the addiction known as wanderlust. That spirit inside you that beckons you to explore and see the world and to photograph it through your eyes.

This book is for you—to inspire you to explore, capture, create, and share your experiences with others. Go tell stories of distant lands, journeys, and culture through your images.

Photography has the power to bring people together from all over the world. I am grateful to be a part of something so special and am excited you are taking the journey with me.

This book is for you, wanderlust photographer.

Twenty years from now you will be more disappointed by the things that you didn't do than by the ones you did do. So throw off the bowlines. Sail away from the safe harbor. Catch the trade winds in your sails. Explore. Dream. Discover.

—Mark Twain

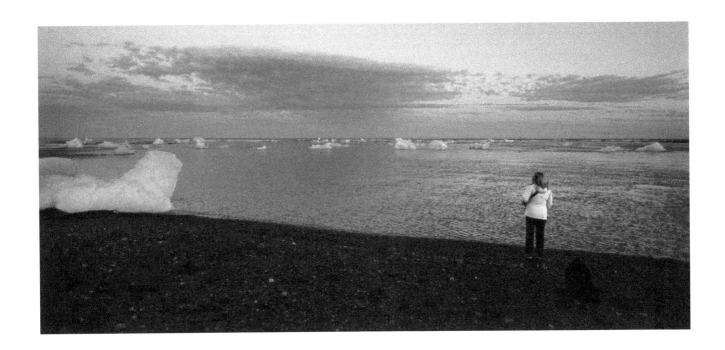

Contents

Introduction

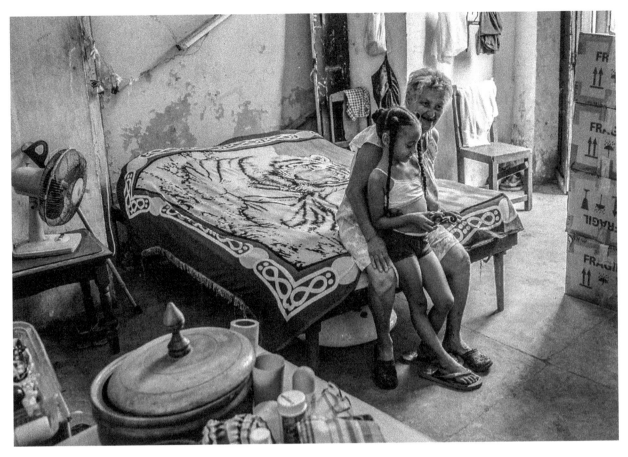

I was invited into a dilapidated building, up a precarious iron spiral staircase, down a hall, through a small door, and into an apartment. Here I found this grandmother and child sharing a moment. These are the moments in photography and travel that you can never forget.

—David McKay

Photography Demystified—Your Guide to the World of Travel Photography—How to Explore, See, and Photograph the World is a book written for those that love to travel, explore, adventure, and photograph.

Many photographers wanting to embark on a photographic adventure are not sure where exactly to begin. Often they find themselves asking not only photography technique questions but also seeking practical advice—*How should I pack my gear? What's the best way to take my cameras and equipment on an airplane safely? What about getting through security in a foreign country, how does that work?* And other questions related to traveling and carrying photography equipment.

Photography Demystified—Your Guide to the World of Travel Photography—How to Explore, See, and Photograph the World is a dedicated to giving you practical advice, so you can get the most out of your travel photography experience. This book will help you and your gear get to your destination/s practically and safely. I present what I have learned through years of travel and leading photographic tours. Additionally, the travel photographer will receive specific insight into creating photographs of their travels that are both stunning and captivating, in terms of the stories they tell.

Along with my wife, Ally, I own McKay Photography Academy. I have taught over 12 thousand people, just like you, photography. For the past five years, I have also led hundreds of beginning photographers and photo enthusiasts on photographic tours around the world—to Cuba, Europe, Tanzania, and Iceland—among many other places. With that experience, I am able to bring you knowledge that sometimes I have had to learn the hard way. These insights alone will save you hours of frustration and will help to make sure your photographic travel experiences live up to everything you dream of.

Having earned the titles of Master of Photography and Master of Photographic Craftsmen from Professional Photographers of America, the leading photography organization in the world, I have been a fulltime professional photographer for over twenty-nine years and am passionate about teaching others how to achieve great results in their photography. My heart's aim is to see that everyone can enjoy photography and to take the frustration out of the process!

The photographic education, tips, and travel knowledge you are about to read are proven methods to help people create the finest photographs of their travels. Take control of your photographic journey right now, make it productive, and enjoy the results of capturing the travel photographs you always dreamed of.

For those that have not yet read my first two international best-selling books in the *Photography Demystified* series, I would highly recommend doing so, unless **you already have a firm grasp of manual settings and an understanding of light**. Even if you do, I believe there is some valuable information for everyone and all levels of photographers in those first two books.

While my first two books are by no means required in order to enjoy and gain valuable knowledge from this book, you will get the most out of this third book in the series, and in your travel photography, by understanding how to use manual settings on your camera system as well as other aspects of photography, such as working with light, that are foundational to creating amazing photographs. These are all taught in my first book *Photography Demystified—Your Guide to Gaining Creative Control and Taking Amazing Photographs*.

My second book, *Photography Demystified—Your Guide to Exploring Light and Creative Ideas, Taking You to the Next Level*, was designed to get you out and shooting specific situations, such as landscapes, street scenes, and nightscapes. It goes heavily into aspects of light and times of day to photograph—which is quite valuable, crucial even, to creating poignant photographs while travelling.

This book will take the knowledge you will have gained from the first two books in the series, build upon it, and apply it to the incredible world of travel photography. This book is NOT a book about the settings and the "how-to" of a camera. Please read the first books in the series for that valuable information!

It is my sincere hope that after reading this book as well as my others, you once again feel my passion for travel and photography, become more confident in your abilities, and are ready more than ever before to create amazing photographs of your journey!

Happy travels,

—David

Foreword

Despite living less than three miles away from David for nearly ten years, having many mutual friends, and attending the same church, it took my moving to Chicago before I booked a spot in his Pro Academy Class and got to know him. I wish it hadn't taken me so long . . . The friendships I have developed with David and his wife, Ally, as well as his staff and other McKay Safari participants have been tremendous. I'm thankful every day for his influence on me as an artist.

I run a photography business specializing in commercial and residential real estate, portrait, and corporate events. As I explain to people, "After receiving my bachelor's degree in business administration and spending nearly two successful decades in the corporate world, I decided to step out and follow my passion of becoming a professional photographer."

Although this is true and it did happen, it's only when I look back that I realize photography is simply the medium I use to express myself as an artist. I don't think I'm alone. We (human beings that is) have an amazing gift to be able to assemble and create things. We have a deep appreciation for aesthetics, beauty, and choice.

Beyond simply living to survive, we are driven to live a "full life," one that is connected to other people, places, animals and designs that inspires inner joy. I didn't simply leave a stable, well-paid, predictable corporate job to start my own business. *With David's help and the travels that followed, I have discovered that I have always been an artist trying to fit into a corporate mold.*

Realizing this was profound. It has taken me from experiencing life in two dimensions, to three. For example, let's say you read all about visiting Paris and seeing the Eiffel Tower. You study the best time to go, search the Internet for images and testimonials, talk with friends who have been, and even find yourself daydreaming about it. Finally, the day comes when you actually go. The experience has gone from an idea to reality. The smell of the air, the sound of a busy city below, the feel of large steel rivets holding the iconic structure together under your fingers are small but significant insights into a new, authentic memory only achieved by being there yourself.

Perhaps the trip didn't play out exactly the way you expected, but I'd be willing to bet that you'd come home with 100 times more knowledge (and maybe wisdom) versus what your daydream gave you. In reflection, you may even recognize a purpose for being there at that particular time. A moment when you say, "I was always meant to have that experience in my life." It may not have been what you expected, but it was what you needed. Having great photographs as a reminder is the icing on the cake!

My first big photography travel adventure was to Iceland with McKay Photography Academy. It was arranged a year in advance, and since I'd wanted to visit the country for nearly a decade, I was both excited and nervous. I hadn't done much traveling outside of the US and the thought of keeping all my gear organized, while remaining safe, was a concern.

What I quickly realized, however, was that being prepared in advance and consulting with David about what to expect, I was more than ready for any challenges that could come my way. This enabled me to focus (pun intended) on taking in the moment and the scenes.

When I returned home, the first thing I told family and friends was *"I've never felt more in the moment, than being a visitor taking pictures in a foreign land. I was the best version of myself."* A desire to take outstanding photographs only helped me slow down and study the land and people.

This slow study brought intricate details to life, helping me to capture present moment for a lifetime. It's easy to reflect on the past and worry about the future when we're going about a normal day at home. And it's traveling that helps keep us humble, thankful, and aware of life at that very moment. The friendships that we develop from these adventures are built on a foundation of amazing shared experiences. And it is these friendships that I reflect on daily.

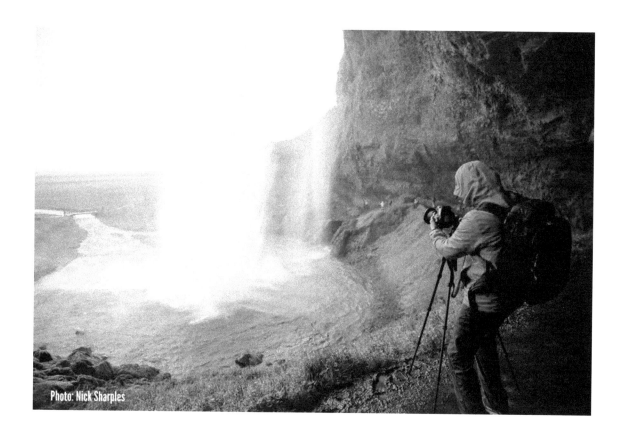

Photo: Nick Sharples

Since the Iceland trip, I have become inspired to experience more! Travel photography has taken me to Paris, Arizona, Yosemite, San Francisco, Utah, and up and down the California Coast. Later this year, I'll be with the McKays to Amsterdam, Tanzania, Scotland, New England, and coastal Maine.

My future dream trips include Alaska, Croatia, Italy, Ireland, Patagonia, and Antarctica. In fact, when my wife retires in a few years, we're already planning a yearlong sabbatical to travel and

photograph various international locations, and meet new friends. Planning and doing this has become easier than ever, once we decided to step out and make it a priority. The walls of our home are literally soon to be filled with large, framed metallic prints of our adventures. What a joy to come home and have "our story" off of the memory card and on display. What started as a trip to Iceland, a place I wanted to visit and photograph, has completely turned into a way of life.

What is my point in telling you all this?

In order to get something you've never had, you may need to do something you've never done. Move, go, do, try, or step into the unknown. It may not start as a major leap from one career to another or booking an airline ticket to Iceland to photograph vast landscapes (although I highly recommend this one), it can simply be to read this book and start by visiting a local site with your camera to practice documenting the experience. In the pages ahead, David reminds us to be travelers first and photographers second. I couldn't agree more. In my own life, I am an artist first and a documentarian second.

David and his team have invited me along to serve as a McKay Academy Instructor from time to time, which is one of the greatest compliments and experiences I have had in life. When I'm working one-on-one with a client, discussing camera settings, framing a composition, or studying light—nothing is more rewarding than a moment when they step back from their camera, look at a photo they've just taken, and share the joy they are having in learning how to take first-class pictures in amazing places.

This third book in David's highly successful *Photography Demystified* series, *Your Guide to the World of Travel Photography*, taps into our deep human desire to explore and remember. This, in my opinion, is much better experienced with others along the way.

Meeting and fostering a friendship with David took ten years and 2,000 miles distance in the making, but it didn't have to be. His teaching is not only easily accessible through his writing but also in person on photographic travel tours all over the world for people just like you and me.

Dear friend, wherever you are, I hope to meet you someday soon.

Blessings,
Steve

Steve Scurich Photography
www.stevescurich.com

Part One

The Experience

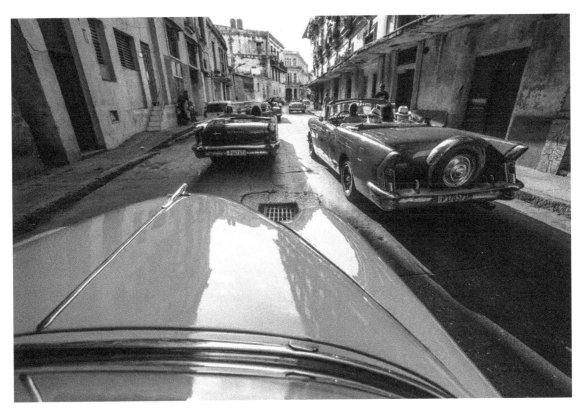

We took our Cuba photography tour group, rented eight beautiful classic American cars, and drove through the streets of Havana. What a blast! These type of experiences are often the things that you not only will never forget, but they will help you to be inspired to create even better photographs!

1—Traveler First, Photographer Second

As we begin this journey into the world of travel and photography, I'd like to share what I have seen from so many photography enthusiasts over the years. Many consider themselves photographers first, and their travel is secondary to them. As much as this is a book about travel photography, I want to start with my belief that you should be a traveler first and a photographer second. Not the other way around.

In stating this, I can already see some of the emails coming my way, explaining, "We must hone our craft as photographers first, learning all of the techniques for the best depth in an image, to ensure sure we know our 'stuff' first before ever heading out on a journey."

To this I say a resounding NO! Please understand—I DO believe in those things, but the reason to learn them is *not* because you're a photographer first. It is because you are a traveler who loves photography.

If you are reading this book, I assume you suffer from the wanderlust addiction many of us, including myself, do. You are not content staying put in one location and sitting on the sofa for the rest of your days. You do not want to go through life in a menagerie of daily routine and boredom.

You, my friend, are a person that wants to see the world, experience culture, understand life in faraway places, and explore this amazing planet we live on! You are a *traveler*.

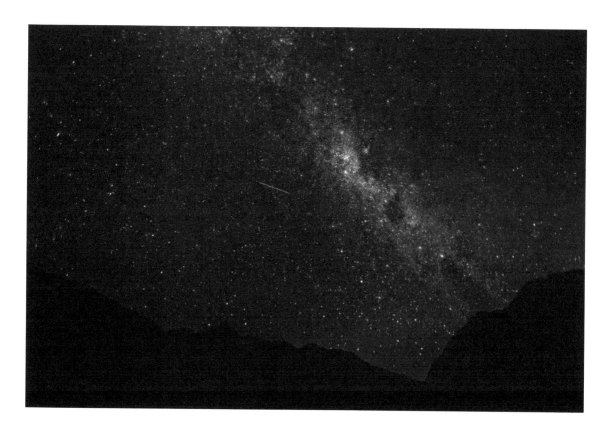

Photography just so happens to be the medium by which you will create, capture, tell the stories of, and share all the amazing places you explore and people you meet on your journey. Photography is your way to share your experience. How cool is that?

2—Why the Experience First?

If you have read my first two books, you know that I believe that photographs can fall far short of what they are capable of if they lack emotion and story-telling elements. To have an excellent image in terms of technique and skill does not mean that you have truly captured the essence of the scene or subject you are photographing. Worse yet, that lack of emotion will certainly translate to the viewer, either leaving them wanting more or encouraging them to not give much attention at all to the photo.

The same can be said of a photograph that is full of emotion and an incredible story but is lacking in the photographic skill to do it justice. We must have both technical skill and emotional impact to truly show what we intend.

Here is an excerpt from my first book in the *Photography Demystified* series:

> Whether you are using your phone or the latest and greatest camera available, taking in the moment, and all it has to offer, is really the foundation of a great photograph. Only then, from your heart, can you capture that moment that tells the story as you saw it and experienced it at that time. These are the images that will speak to others and these are the images you will cherish forever. Why? Because they contain emotion behind them. People will always connect to that.

Maybe you have heard the saying that a camera doesn't make a great picture, the person behind it does. This is a truth you must adhere to.

It is only when the person behind the camera takes everything they are feeling, sensing, and taking part in, and combines it with their technical skill at the moment the shutter is released, that truly great photographs are conceived.

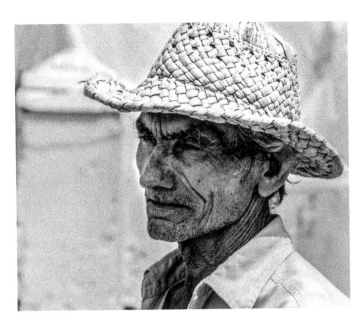

I implore you to always see and feel first, before ever pushing the shutter.

One of my favorite movies is *The Secret Life of Walter Mitty*. If you have not yet seen this movie, you owe it to yourself to do so. This is an excellent movie for the traveler and photographer in you!

There is a moment in the film when Sean O'Connell the photographer is set to take a photograph of an elusive snow leopard. Suddenly the leopard appears and instead of shooting right away, he stops. When asked why he stopped, he replies, "If I like a moment, for me, personally, I don't like to have the distraction of the camera. I just want to stay in it."

That moment in the film has stuck with me ever since I first saw it. It is so easy to be so fixated on the "shot," on the shutter speed and aperture settings, whether the camera is level or not, and the list goes on, that we can simply truly miss moments in our life that really matter, the moment where we can take it in, enjoy it, remember it, and *then* photograph it.

From here on out, my personal assignment to you is this first and foremost: Be sure to experience and enjoy the moments as you travel first. <u>*Then*</u> apply what you see, what you feel, what you taste, what you smell, and whatever emotions you may be feeling at the time, to your photograph.

In doing so, your images will be filled with your emotions. Your photographs will take on new meaning for you and for others. Rather than just having a "picture," you will have created a story. Everything in your image will flow out of this. The way you compose the image, which settings you choose, what you include in the frame, all will have new meaning. Why? Because you now have a purpose with the image rather than to just take a picture.

The image below was taken in Havana. I sat and watched these boys enjoying life and being outside playing rather than on video games. They may not have much, but they have this, and this is wonderful.

I watched for several minutes before ever taking a photograph and let my thoughts take over first.

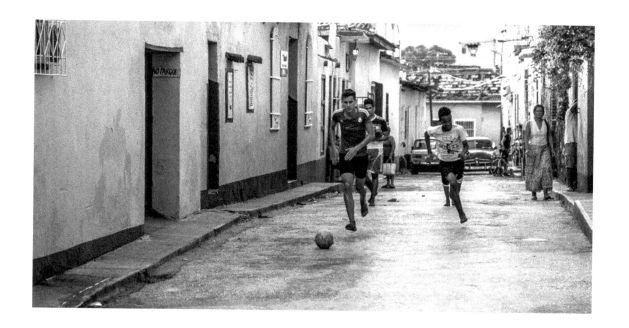

Part Two

Before You Go

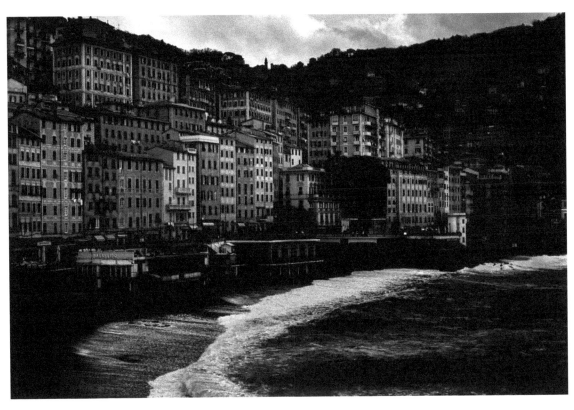

The image above was photographed in Camogli, Italy. This was the first time Ally and I had ever traveled outside of the US together. It was here that we really feel in love, and this is our favorite town in the world. We have been back four times now sharing this beautiful "hidden" location with others.

If you have read my other books or taken a class from me, you know that I believe in a solid foundation. I know that the more you prepare, the better your foundation will be and, therefore, the more success and enjoyment you will have as you travel and photograph.

Whereas my other books focus on learning manual settings, understanding exposure, working with various types of light and more, this book is about making sure all of that knowledge is not wasted because of mistakes in the travel process.

Quite frankly, I want to help you ahead of your travels so that everything you have learned in photography up until now can be used to its fullest ability and to your fullest enjoyment. I want your travel photography experience to be epic.

I also know that I have learned much of this the hard way and I want to save you that process. Some of you, particularly those of you who are well traveled, may think that what I will share is obvious, so I ask you to remember the first time you set foot on an airplane or went to another country. The process can be quite intimidating for the new traveler, and I am writing to make sure they are well informed, prepared, and equipped for success.

3—Choosing a Destination

So many choices, so little time or resources, how do you choose where to go? This is a difficult question to answer, isn't it?

The first item I usually ask myself is this, "Is this a destination with photography as the main objective, or is this a trip to lie on the beach somewhere?" If the answer is that it is primarily photography, then I narrow down based on that. Sure, I will still take gear with me if I am going to a beach resort, but what I bring and my attitude towards the trip are vastly different.

For purposes of this book, as it is a travel photography book, let's assume you are choosing a destination based on photography. If I am looking for a place that I have never been, I scour the Internet, researching top photography sites and tours.

I like to get off the beaten path a bit but also enjoy some touristy activities in locations. A big part of the equation also is about the subject matter I want to photograph. The first step should be deciding on the subject matter that most interests you.

If I am looking to photograph Old-World architecture and history, I might consider locations throughout Europe, such as Italy or Greece. If I am considering wildlife, Tanzania may be my choice. For culture, something unique, such as Cuba or Vietnam, would be a great choice. Landscape might be Iceland or New Zealand.

There are literally thousands of choices; however, deciding on a subject that is important to you for experience and photography will help narrow it down.

For myself and my wanderlust addiction—I love it all. I truly do! With that, I just have to decide what it is I am looking for at the moment. For you, that may be different.

4—Once a Destination Is Chosen

Once you have decided on a destination, or at least the type of trip you want to take, it is time to research. I know I own a photography tour company, so you may think I am biased, and I am, but if you want to really photograph, be with like-minded people that do not care if you stop every five feet to take a shot, and want to gain in your photography skill all while seeing the best spots, a photography-specific tour is an awesome way to go.

Going It Alone

For some of you, you prefer to go it alone. Your wanderlust addiction prefers being by yourself and just taking each day as it comes. No schedules, no time limits, and no others to deal with. This is a nice way to go if you are totally comfortable with traveling by yourself, and you enjoy the adventure. With the Internet nowadays, you can do tons of research ahead of time. Plan out some ideas of where you want to be and when, and then make it happen.

If you are planning a trip on your own, go online and look for photographers in the areas where you will be going. I have never once reached out to a fellow photographer and been turned away.

One of the special aspects of the photography world is that most of the time, we are a kindred bunch of people. With this, people from all walks of life find the ability to connect. I have found that by connecting with others in locations around the world, I not only have developed friendships but have gained valuable knowledge on areas, local customs, and hidden gems that I would have never known about.

If you are comfortable traveling alone, you feel safe in doing so, and you are able to handle the unexpected (that will happen) on your own, absolutely go for it. More power to you and your solidarity in traveling this way. It can be quite rewarding and adventurous.

I highly recommend making sure, at the very least, you let people know where you are!

Photography Tours

There are many reasons a photography tour company may be the best fit for you. First, the obvious, you love to travel and photograph. These companies are set up for exactly that.

A regular style "bus tour" will not afford you the time or patience for doing what you want. I am sure many of you reading this book have experienced getting to a location on a bus tour, only to be told it was time to go literally 5 to 10 minutes after having arrived. Welcome to a regular tour group. I lead tours in Yosemite quite a bit, and I see the buses roll in and roll out over and over, typically only staying in a spot for a few minutes.

Another situation you have probably experienced is traveling with family. Although this is great for family vacations, it is not always suited for your photography needs. You may find yourself being

told to hurry up or that "we have to go because the kids are hungry." I think many of you understand what I am saying!

These are just a few of the reasons traveling specifically with a photographic tour may be a good fit for you.

There are many photography tour companies out there. Yes, I feel like ours is top-notch, and I believe our clients would tell you the same thing. But we are not the right fit for everyone, nor do we try to be. In fact, we have actually said that to potential clients because the last thing anyone wants on a tour is incompatibility.

Our company, McKay Photography Academy, specifically wants everyone, no matter what their photographic skill level, to feel welcome and not intimidated. We do not allow for the ego of a person thinking they are the next great National Geographic photographer to take over. There is no place for that in a group like ours, and no one wants to feel that.

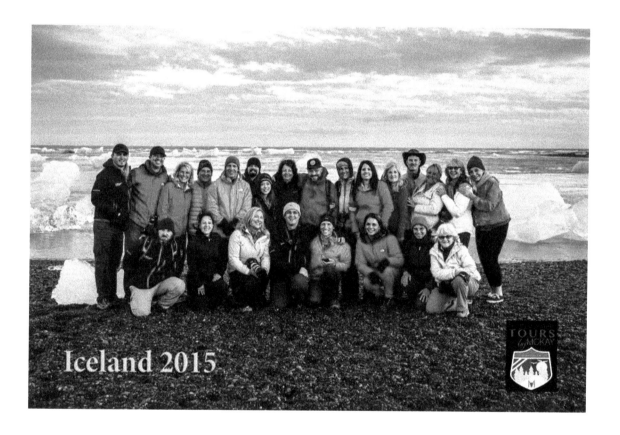

There are companies that specialize in photographers that already really know their stuff and prefer to cater to a client that knows every setting and situation. That may be for you or may not be. Be prepared on a tour like that to fight for your spot and to be able to hang with the best. That is not a bad thing; it just is a different fit than others.

The first step in choosing a photography tour company is to research and decide what it is you want in a tour. Price can be important, understandably; however, nothing is worse than a bad situation, and sometimes, the lowest price can be reflective of this. There is a difference between low prices, bad service, and corners cut versus high value at a fair price for what is being offered.

Check out websites, ask for referrals, call and talk to people, and see how you like the "feel" of how the tour leaders interact with you. Ask about the person who will be instructing on the trip and the client-to-instructor ratio.

One thing I have learned is that a great photographer does not necessarily mean a great instructor! Do not choose based on the fact that someone is a great photographer alone. Instructors should be patient, kind, uplifting, and encouraging. They should not be in it for themselves to get the best shot over you. The instructor should always put their clients first.

Another great aspect of traveling with a specialized photographic tour is that all of the logistics and planning are done for you. You simply arrive and go. Everything has been thought out and taken care of, leaving you the opportunity to not worry about a thing—except your photography.

The bottom line is this: Anyone can take you to a location and tell you the settings to use, or, worse yet, not say anything. It is the companies that really have a heart for teaching and inspiring, that love to explore and get out and shoot, that I recommend. Whether that is with us or another, make sure you feel welcome and that your needs are met for what you are looking for in a tour and destination.

Of course, I would love to see you join one of our photography tours around the world!

5—Travel Insurance

Making travel arrangements these days is so much easier with the Internet. There are so many websites that help you to find the best prices on everything, from airfare to hotels and car rentals, that the amount of information at your fingertips is truly mind-boggling.

There are apps that you can take with you for languages, choosing restaurants, directions, and more. Technology, like never before, allows us to successfully plan well ahead of time.

However, even with all of this at our fingertips, things can and DO go wrong.

When things go wrong, and they do, travel insurance can help in many situations. My wife and I personally will no longer travel without travel insurance. That is how much I believe in it. As someone that has not only traveled the world but has led tours to many places around the globe, I have seen more than I care to say of things that went wrong.

My question for you is this: Do you like to gamble with thousands of dollars? Without travel insurance, you are doing just that.

Personally, Ally and I have had to file claims twice just this past year on situations that happened to us. Thankfully, travel insurance saved us several thousands of dollars due to some medical issues that happened overseas. In another situation, on our way home after a recent tour, upon landing at JFK, Ally experienced a sudden and non-stop nosebleed that required her to go by ambulance to a hospital emergency room.

Thankfully, both situations ended up being minor. However, the cost for the doctors and incidents were not. That little ambulance ride and 2-hour emergency room visit in Queens, NY, cost $1,800! Travel insurance covered this cost as well as the flight-change fee.

Heed My Warning!

Unfortunately, no matter how hard I insist to people that they need travel insurance, many do not heed my warnings. Many think it is a waste of money and will not be necessary for them. They cannot foresee anything preventing them from taking their trip of a lifetime and see no reason to spend the extra funds to protect their investment.

After sending letters, having clients sign contracts, and warning them 3 to 4 times prior to a tour to get travel insurance, many still do not get it. Then it is so sad when I receive a call from someone saying they cannot make it and asking whether there is anything I can do. In most instances when people have cancelled on a trip, travel insurance would have covered their investment based on their reason, such as illness, loss of a loved one, work-related issues, and more.

The reality is—anything I can do, I do. I tell clients what to do and how important it is. I make sure they know well in advance what can—and does—happen. I do everything I can think of to share ahead of time how vital insurance is, yet I will still get the call asking for help and whether there is anything I can do.

Unfortunately, there isn't much I can do for them at this point. Planning a tour like this takes hundreds of hours of time, monetary commitments to my vendors, work from my employees, contracts from my end that have to be fulfilled, and much more. It is not my responsibility to make sure a client does what they need to do in order to be covered. If you are not protected with travel insurance, you can be out several thousands of dollars.

This is so sad when all it would have taken is a 10-minute phone call and a very small amount of money to protect your investment.

Convinced yet? No? Okay, let me show you things I have seen.

I have personally witnessed people experience:

- Luggage lost
- Items stolen
- Flights missed
- Flights delayed
- Clients' places of work not give them permission to leave

These are just relatively simple situations that can create havoc but that travel insurance can help to recover costs from.

Now, for the really bad stuff I have witnessed people experience:

- Illness preventing them from a trip
- Illness on a trip
- Broken limbs on a trip
- Surgery having to take place on a trip
- Death of a loved one prior to leaving
- Divorce
- Job loss
- Being seriously hurt prior to a trip

Yes, this is what I have seen. If you are not convinced yet, let me keep going.

Every trip we have ever scheduled has had someone not able to attend. Many times it has come up within a day or two of the trip's departure date. There have been heart-breaking stories I have heard. For those that have travel insurance, they have found comfort knowing their investment was not lost.

For those that did not, they were out not only their funds to their tour provider, but their plane fare costs, the optional tours they paid for, and any other investments into the trip they may have made.

Now are you convinced? Good, you should be.

Insurance Providers

There are a lot of travel insurance providers. Many are good, and some are not. The first rule in purchasing travel insurance is not to do it through your airline when booking your flights. Typically, you will spend more for less coverage, and it can be difficult to file claims.

I recommend purchasing a policy that fits exactly what you need. There are a lot of variables, and obtaining what is best for you at the best price is important.

We personally work with Brandon Hughbanks of Travel Insurance Center. The reason is that as an agent, he has access to all of the major carriers, and based on our specific needs, he can shop those for us to get the best rates and coverage.

He also only works with very reputable companies such as Travel Guard, Travel Ex, and others that take care of his clients. By no means is he the only one, and, of course, you can purchase on your own.

We personally have just found him to be a great resource for our clients. He has helped many of them obtain the best policies at far better rates than they could on their own.

Brandon Hughbanks
Agent Representative
Toll Free: 1-866-979-6753 Ext. 3636
Direct: 402-343-3636
Fax: 402-343-9959
bhughbanks@travelinsurancecenter.com
www.TravelInsuranceCenter.com

It is important to note that I (and my business and my wife) am not in any way affiliated with any of the products I endorse within this book, other than the fact I believe they are exceptional products, I use them all personally myself, and I find them to be an excellent resource for clients. In some instances, my business may receive a small referral amount, a discount on a product, a marketing partnership, a free product, or promotional materials by endorsing a product. However, I only work with products and people I value, believe in, and use personally, based on quality and what I already use.

6—Equipment Insurance

Another insurance I find a must-have is protection for your gear. Unfortunately, many people travel, thinking that all of their gear is covered under their homeowner's policy. This may or may not be the case. You definitely want to make sure you know what is covered exactly and what is not, as well as the amount of coverage and the deductible, should something be lost due to theft or breakage.

When considering equipment insurance, there are basically three options to consider:

1. Home insurance policy

2. Professional membership organizations

3. Private insurance carriers

It is important to note that regarding insurance, I cannot give actual legal advice. You must talk to your agents in regards to actual coverage and benefits.

Home Insurance Policy

Most people tend to already have in place a homeowners or renters insurance policy. However, this type of insurance typically offers the least coverage for your gear. The benefits of homeowners insurance as the sole insurance for protecting your gear are that it is inexpensive and if you do not own that much gear, it may be all you need.

However, the deductibles may outweigh the cost of new gear. Also, the coverage usually doesn't allow for accidental breakage, such as dropping and breaking equipment. On top of that, it may not offer coverage problems that occur outside of the US.

If you operate as a professional photographer in any capacity, homeowners or renters insurance also does not cover you.

Be sure to check with your agent to understand exactly what is covered and the cost associated with replacing it.

Professional Membership Organizations

Organizations, such as Professional Photographers of America (PPA), are an excellent resource to not only gain coverage but to gain education as well. For around $300 a year, payable in monthly installments, you get all of the benefits of being a member AND $15,000 of gear coverage. That is less than purchasing a policy on its own and offers excellent coverage, including for travel outside of the US.

Even if you are not a working professional, joining an organization, such as PPA, is extremely valuable for both the educational benefits and the insurance coverage.

For very little money, you can also increase the amount of coverage needed if you own more than $15,000 in gear.

http://www.ppa.com

Private Insurance Carriers

If you want coverage that pretty much protects your gear against anything. A private carrier such as InsureMyEquipment.com is the way to go. You will spend more on your policy, but it comes with very extensive coverage.

7—Flexibility and Your Itinerary

Once again, with the Internet and so much available at tour fingertips, you should develop a base itinerary of where you want to go and how to get from point A to point B along the way.

With this said, do not over-plan it! I like to develop a basic outline of what I am working to accomplish on my journey. The outline serves as a guide but still allows me the freedom to have flexibility along the way.

Those of you reading this that have traveled with us in the past know that our number one word on any tour is FLEXIBILITY!

Flexibility is a MUST when photography is the primary purpose of your trip. If you are so locked into every aspect of a trip down to the minute of every day, you will find that you have no ability to just have time to explore and change plans as you go. There are so many variables that take place.

I may plan on going left down an alleyway only to turn right because something catches my interest. There have been so many instances on my travels when I thought I would be doing one thing, and plans totally changed because other opportunities arose.

The variables that can happen are so many that if you are locked into every moment, you may miss great light, hanging with the locals, and just the fun of getting "lost" in a place, like Venice, for example.

With all this in mind, I recommend determining the basics of locations you are interested in—planning how to get there, places to stay, and generally what you want to do and where some of the top photographic locations are in the area.

Yet, in the name of flexibility, be willing to change and go with the flow as it comes. Some of my greatest images have come out of situations I would have never been able to plan for!

> **TIP:** Triposo is one of my favorite apps for helping me explore locations where I want to travel in a country.

8—Booking Flights

The Internet makes things so much easier. I personally find that Kayak does a great job of showing various airlines and rates. I also like that if I book through Kayak, I can purchase directly from the airline itself as it refers the user to the airline website.

When booking flights, I do not recommend booking through companies, such as Orbitz, Expedia, or others, UNLESS you are directed to the actual airline site. This is due to the fact that if you have an issue with a flight, you have to talk to them directly—the airline can't help you.

It is incredibly frustrating to have some type of situation arise with a flight and the airline tells you that you have to speak with the company that you booked through. Imagine if you are out of country, at an airport, working to figure something out, and you can't talk to the airline directly. Trust me—not fun—and I have learned this the hard way.

For this reason, when purchasing flights, I highly recommend making sure the booking is directly through the airline.

Of course, if you fly as much as I do, you also have status on carriers, which makes things easier in some aspects.

Choosing the Airline

Not all airlines are the same. I have my favorites and can tell you horror stories about others. Even my favorites though are not always up to par. The fact is, the airline industry is no longer the glamorous, fun atmosphere it once was. Flying is stressful, period.

Since flying is stressful, I do as much as I can beforehand to soften the situation. As I fly from the US and have status on a few airlines, I have found that it is much better to be sure that my originating flights are with the carriers I have status with. NOT with their partners. This may not matter to you if you do not have status on a particular airline. However, I also find that it is easier to communicate with a US-based airline rather than a foreign airline. In emergency travel situations, this can play a major role in your ability to solve an issue.

An example of this would be the United partners in the Star Alliance. If you are flying to Frankfurt from San Francisco, it is very possible that Lufthansa will be your airline even if you booked through United.

Lufthansa is an excellent airline; however, my status on United Airlines goes farther when I actually am on a United Airlines plane. The miles I receive as a frequent flier are also better. Additionally, it is much easier to choose seats, get upgrades, and talk to someone if necessary.

The last time I had a flight on Lufthansa that was booked through United this happened. Ally and I walked up to the entrance of the loading platform about to board. We were informed by the agent

checking our tickets that they had changed our seats. We ended up stuck in the middle all the way to Frankfurt, despite the fact we had chosen our seats months in advance. Our "status" on United was thrown out the window, probably for someone with status on Lufthansa.

They may be in "alliance" with each other, but, trust me, they do not talk to each other and you have to work directly with whatever carrier you happen to be on. This is the same for Delta Sky Team or American Oneworld partners.

Another issue that arises with "partner" carriers is that of baggage allowance. One time Ally and I had to fly from Rome and were on a Brussels airlines for the first part of the trip back home. Upon checking in, they asked to weigh our carry-on luggage. As we travel with our photography gear, you can guess what happened. We were overweight for their airline by a LOT.

My argument that as United Status members and the fact we travel all over the world and never have to deal with this, etc., was met with a look of "So what? Pay the fees or do not fly."

If we had been on a United Airlines plane, this would never have happened. The money I may have saved at booking caught up with me in the end. Of course, it is not always possible to avoid being on a partner airline on a portion of your itinerary, but I try to avoid it as much as possible.

A way to avoid this is that as you are looking at your flight possibilities, look to see what the actual airline carrier will be for each portion of the trip as well as the type of aircraft you will be on. (I will discuss why the aircraft matters soon.)

As I have status on a few different airlines, I always try to book my flights to be on the actual carrier I prefer in order to avoid what happened in the examples above. Even if it means spending a little extra money, the experience is worth it I have found and usually pays for itself in the end. Especially if something goes wrong. If you are on a partner airline, you are placed last when it comes to flight delays, lost baggage, and more. They will work with their priority customers first and then you.

Often times you may find you have to be on a partner airline as part of the itinerary. Of course, you cannot always avoid it, but I recommend avoiding it as much as you can.

> **TIP:** If you plan on flying quite a bit, it is in your best interest to have not only frequent flier miles adding up but also an airline-specific credit card. By using your airline credit card to book your flights through the airline directly, you get free luggage allowance, and your miles in many cases are doubled for that purchase. I'll discuss this more shortly.

TSA Precheck and Global Entry

If you dread going through the endless security line, taking off your shoes, being body scanned, taking out your laptop and iPad in order to get through security, you are not alone.

TSA Precheck and Global Entry status is something you should consider. If you are travelling internationally often, you should go ahead and just obtain your Global Entry as it serves as a TSA Precheck as well.

By paying a nominal fee, going through a security background check, and upon receiving approval, you will no longer have to wait in all those long security lines (in the US portion of the journey, as it doesn't apply outside of the US).

With Global Entry, upon reentry into the US, you simply walk up to a kiosk, place your passport in, and you are on your way, once again avoiding long lines and delays.

Check the Global Entry web site: http://www.cbp.gov/travel/trusted-traveler-programs/global-entry for more information on how to apply and do the interview process.

The TSA Precheck program website is here: https://www.tsa.gov/tsa-precheck

> **TIP:** Some credit card companies, such as American Express, will refund your application fee. Check to see if your does.
>
> When booking your flights, make sure your known traveler ID number (KTN which stands for "known traveler number") is in your information if you have obtained TSA Precheck or Global Entry status. This will help ensure you receive "pre-check" on your boarding card.

Having a known traveler ID number/KTN does not guarantee Precheck status, so when checking in, make sure the ID number and status are evident on your boarding pass. If not, ask your agent to add it.

Airline Credit Cards

If you do not already have an airline credit card, this can be an excellent option as you start to travel. I have two different airline cards I use. Depending on what flights I need, I may choose one airline over the other although I try to stay with one airline as much as possible for status reasons.

The first benefit is that usually once you spend a certain amount on the card, you receive a large portion of miles. The credit card and airline industry has become very completive as of late, and I have seen offers for 50,000 miles by using a card. That is enough for two round-trip domestic flights or even a flight to Europe, as an example.

Another great benefit is that when you book your flights, if you use an airline credit card, you usually are awarded double the miles for the purchase dollar amount.

One of the best benefits is that when you book your flight with the airline card, you also get two additional bags checked for free and you get priority boarding. This can save you on not only your luggage fees but the headache of boarding last and not getting that coveted overhead bin space!

TIP: In order to get the benefits of additional, free luggage and priority boarding, you MUST book your flights with the airline credit card. Just having the card does not gain you the benefits.

Why the Type of Plane Matters

I mentioned earlier about not only checking to see what the actual carrier is on each portion of your flights but also the type of aircraft you will be on.

When you are traveling with expensive photography gear, the last thing you want to be told is that you have to check it in! If you are on a smaller regional jet, as an example, chances are you will have to hand off your gear to a luggage handler as you are boarding.

This can give you quite the uneasy feeling as you watch your thousands of dollars in gear get thrown onto a belt and you hope it is waiting for you when you land. For this reason, I am always trying to book flights on a larger aircraft if possible.

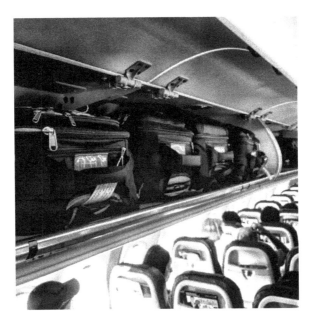

Here is an overhead loaded with four bags of our team's gear!

If it is not possible, I always ask the luggage handler taking my luggage to please make sure it is not thrown, and I take my laptop out. If it happens on a return flight from a trip, I also remove my memory cards and keep them with me. Then I hand over my precious bag of gear and watch as the person places it on the belt, thanking them for doing so. In these situations, you collect your gear as you depart the plane, not in the baggage claim area.

> **TIP:** If you are asked to check your gear as you board and they place a tag on it even after you explain that you cannot part with it, if you know the plane is large enough to handle your bag in the overhead or under your seat, simply tear it off inconspicuously as you go down the boarding ramp. These tags are not loaded into the system and the flight attendants have no knowledge of the fact you were "tagged' at the gate.

Foreign (Non-US) Airline Restrictions

What happens if you find yourself in a situation where you have no choice but to be on a foreign airline? You must be prepared for the rules and restrictions that will be thrown at you at check-in.

Most of these airlines are very strict about their carry-on polices. Many have limits of one bag, weighing 15 pounds maximum. My camera bag weighs well over this.

Unfortunately, you have to hope for the best and smile a lot at the ticket counter. There are also a few tricks we have learned along the way.

1. If you are flying with friends, have them watch your gear out of site from the agents while you check in. Then do the same for them. This will avoid the agent looking at your larger carry-on and asking to weigh it.

2. If you have to go to the counter with your carry-on, it is better if it is a backpack that you are wearing. *Usually* they will not ask you to take it off and weigh it.

3. If you are rolling up a carry-on, as you approach the ticket counter, roll it up to the counter and keep it out of sight of the agent sitting at the desk by keeping it in directly front of the counter. The saying "Out of sight out of mind" comes into play here.

4. Check-in when they are busy. We have found that if there are lines of people, the agents do not want to take the time to "figure it out." They would rather get through the line of people waiting.

On our trip home from Fiji recently, we had no option but to go up to the ticket counter at a very slow time. We were second in line. There was not only the ticket agent; there was another agent whose sole responsibility was to weigh carry-on luggage and make sure each piece fit into the tiny "test" crate.

As we approached, I smiled and chatted, doing everything I could. At the end of ticketing, I thought it was all good. I was wrong. The following comical dialogue took place.

Agent: Okay sir, I need to weigh your carry-on (meaning my roller camera bag).

[*Knowing very well what is about to happen, in mock-surprise, I reply with the following.*]

Me: Oh . . . okay.

Agent: Sir, your bag is very overweight. You must check it.

Me: Miss, I am so sorry. I know that you have rules that are far different than other airlines. I have flown with this all over the world, and it is my very expensive photography gear. Please make an exception. This is a large Boeing 777 airline, and I know there is plenty of room because I fly on them all the time.

Agent: I'm sorry sir. You must check it. Does it fit in our test bin?

[*Because the agent makes me check, I proceed to stuff it into the bin. Yes, it fits, but still it's over their weight limit which continues to be an issue . . .*]

Me: I'm sorry, I cannot check my bag though.

Agent: I am just doing my job, sir.

Me: I know and understand. However, I am unable to check this bag of precious cargo. What is the extra fee?

Agent: Sir, there is no extra fee, it is just too heavy.

Me: Well, I do not know what to do. I simply cannot check it, and, honestly, I see no reason why I should have to, considering this bag has flown all over the world with me with no other problems. What can I do to help this work?

[*I ask, smiling the whole time and acting like I do not know what I can do. At this time a line of people is starting to form behind me, and I can see the agent getting flustered knowing she is going to be put behind schedule.*]

Agent: Okay, go ahead and take out your cameras and then let's weigh it.

Me: Okay.

[*I proceed to take the cameras out of the bag, and my heavy lens. The agent weighs the bag.*]

Agent: Okay, it's good.

[*Then she moves to place the "okay" boarding tag on my bag.*]

Me: Thanks for working with me. Have a nice day.

As I walked away, carrying my camera gear in my hands, I then placed it back in my roller camera bag once out of sight. At this point I was rolling along my one carry-on bag that was now "okay" because it weighed in fine while I held the gear in my hands.

Ally had to do the same thing.

As we were leaving, Ally asked the agent, "Isn't the weight the same we are carrying on regardless of if the cameras are in the carry-on bag or on our shoulders?"

I chuckled and said, "Ally, do not push it. Let's go!"

TIP: I now wear a vest with a lot of pockets in it when carry-on luggage weight may be questionable. Scottevest is a great brand for this. Before getting in line at a ticket counter, I check to see if they are weighing carry-on luggage. If so, which is rare, I simply stuff camera gear into my pockets and then after they weigh the bag, re-pack it once out of sight.

9—What Photography Gear Do You Bring?

If you ask ten photographers this same question, you'll probably get ten different answers! The question of gear choice is a very personal subject. The answer is different for different photographers because so many of us "see" differently and have different ideas on what we like to photograph.

For me, I usually ask myself what the majority of images I plan on shooting are going to be—landscape, people, or wildlife. The answer to that question helps me decide on the gear and lenses I bring.

The type of trip I am doing and how much walking also factor into my decision. One thing I can tell you is that many times on our tours, people bring everything they own. After the first day of walking around with a full load, Ally and I start seeing the equipment and camera bags getting lighter and lighter.

Our rule is that you may want to bring it, but you will not want to carry it all every day! We leave certain items in our hotel locked in our bags, such as extra camera gear, laptops, etc. You will want to travel light when out walking!

My Go-To System

I bring my Think Tank Airport Roller Derby camera bag with everything in it. (See the packing chapter ahead). This bag has been with me all over the world and is truly the best camera bag I have ever owned! Think Tank specializes in camera bags and gear, and they are my favorite camera bags in the world. You will notice I recommend them throughout the book.

The rollers are so good on this bag that it can roll away down a slope! This bag stays in my hotel room with a TSA lock on it holding any gear I may leave behind. Also, it is GREAT for getting around an airport with!

When I go out shooting, if I am going to be walking a lot, I go light! For me, that means taking one camera body with a wide-angle lens on it. Then I have my Think Tank TurnStyle shoulder bag. In this I will have an extra lens, memory cards, and a spare battery.

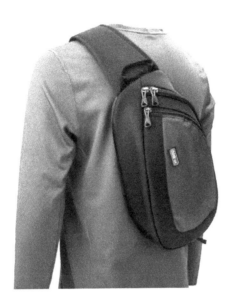

Lenses

I personally love shooting with a wide-angle lens. It is very rare that my 16–35mm wide-angle is not on me. I also almost always have my medium-range lens around. That is my 24–105mm. I find that both of these lenses are excellent for landscapes, alleyways in Europe and other locations, people, and street photography.

My longer lenses are usually what I am trying to decide on. The issue is usually weight. I am not one that likes to carry a ton of gear when I am out walking the around. I also do not like carrying a lot of weight.

With this said, I usually will bring my 70–200mm, but I do not tend to carry it around with me all the time. I may leave it locked in my suitcase in my hotel room. However, if I find something I may want to shoot with it or am driving along somewhere and see something, I can use it if I choose.

My 150–600mm is only brought with me for wildlife trips OR when I will be able to easily get to it without having to carry it long distances, as an example, if I can get to the car or bus easily to retrieve it as wanted. I also have an 85–mm f/1.2 that is an amazing piece of glass. As much as I

love this lens, I find that it is so heavy to walk around, carrying it, that I do not usually bring it while traveling.

Below is the equipment list we send to all of our clients prior to a tour.

Gear List

- Camera(s) (backup body recommended; at minimum, a point-and-shoot as backup)

- Camera lenses (a wide-angle and an overall-type lens recommended)

- Comfortable camera strap

- Camera bag (love Think Tank gear, see below)

- Lightweight carry bag for day excursions (Think Tank TurnStyle 10 sling camera bag)

- Plenty of memory cards!

- 3 batteries and a charger

- Power adapter for countries visiting. Just the adaptor. A transformer not needed.

- Lightweight but sturdy tripod AND extra plate for the camera attached

- Cable release or self-timer on camera for long exposures

- Trigger Trap app is excellent for a release or timed exposures

- Laptop (can be optional but recommended)

- External hard drive!

- Rain sleeve (covers camera and allows shooting in rain)

- Lens cloth or lens wipes

- Knee pads for kneeling on rocks and for comfort

- Small flashlight

Optional: Polarizing filter, ND filters

Backup Camera Body

We always recommend a backup camera body or even a simple, basic backup camera. This is also something that every trip we tend to see a situation happen with. We see cameras stop working, get knocked over, and more. Even a point-and-shoot is better than nothing as a backup option.

As you may be traveling in various conditions, it could happen that you may find yourself unable to get to a camera store. If your camera goes down, it obviously creates a real issue for you. For very little extra money, you should consider renting a backup camera, body if you do not own one, or picking up a decent used backup camera body. The last thing you want to do is get all the way to a destination and NOT get great images!

Tripod

On EVERY tour, we deal with people having very flimsy tripods. You really need a sturdy tripod. By no means do you have to spend big bucks to get one, but a $39 video tripod from the electronics store or the loaner from your uncle will not cut it. There is no sense taking images at night or late evening if your camera is not still.

> **TIP:** A tripod is a necessity for nighttime images and long-exposure images of waterfalls, for example. Having a versatile, lightweight BUT strong tripod is the key. Do not use a video tripod! You will regret a flimsy tripod!

The MeFOTO series is an excellent choice if you are looking for a lightweight yet affordable tripod that does a great job. The RoadTrip model comes in both aluminum and carbon fiber. The carbon fiber model is more expensive but higher quality of the two.

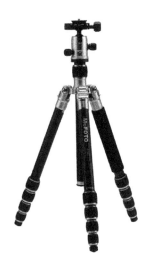

For the price, these tripods are everything most people will need unless they are trying to hold extremely long, heavy lenses.

The tripods also fold up very easily and into a nice compact unit, which is great if you carry it on the plane or if you decide to place it in your luggage.

One other feature that is really handy is that if you have a need for a monopod, this system offers a way in which you can convert it to use as a monopod, thus meaning you do not need to bring both with you!

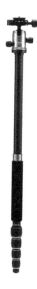

TIP: Always purchase an extra mounting plate for your tripod and keep it in your camera bag. I have seen many people forget their plates or lose them, and then their tripods are useless.

Rental Photography Gear

If you do not own the gear you need and do not want to, or have the budget to purchase it, renting gear is an excellent option! Companies like LensProToGo (our go to company) rent everything you could possibly need for your photography trip including cameras and the best lenses available.

Pricing is very inexpensive and this is a great way to have the very best gear with you that you may not own! www.lensprotogo.com See the coupon code at the end of the book for a discount on your next rental!

Memory Cards

With the price of memory cards becoming so inexpensive, it is highly recommended you bring plenty for a trip. Chances are, you will shoot WAY more than you ever expect, and it really is a bummer to spend $75 on a memory card in another country that you could have brought from the US for $20.

As you are photographing, you want to shoot A LOT to get the best images. It is okay to shoot a lot and get some great ones but a lot of not-so-great ones. I hear from people all the time that say something to the effect of "I only got ten really good ones out of 500." I usually reply, "That's awesome! That's better than Ansel Adams would say. He considered twelve excellent images in a year a great crop!"

Think about how many images Ansel Adams shot in his lifetime, yet he is well-known for a few hundred, at most. Please do not feel bad or discouraged about getting many not-so-good images along with only a few great images. I find that many times by just shooting from different angles and perspectives, I end up surprised later on at the ones I like best. With today's digital technology, go ahead—shoot away!

You should also be learning to shoot in the highest-quality mode of RAW, which uses more memory. I prefer several 32- or 64-gig cards. (See book one for in-depth content on RAW.)

From experience, on every trip people do not bring enough memory cards and have to look for a store. Do not try to shoot everything on one big memory card. If that card goes bad, and all your images are in one place, it will be very painful emotionally to you!

Also, if your camera is older than a couple of years, it may not accept 32- or 64-gig cards. Check to find out by googling your camera model and the memory cards advised.

Downloading may not be easy every day. Also, you will be unable to run to a camera store to purchase cards in many instances. Even if you can, you will most likely pay a high price for something you could have purchased ahead of time.

Make sure that prior to first use and when re-using cards, you format them. You can usually find the formatting option in the menu of your camera. This prepares your card and cleans it much

better than simply deleting files. NEVER format your memory cards until they are backed up in at least two locations.

Downloading/Backup Tips

Download memory cards either to your computer AND an external drive, OR to a computer and save the exposed memory cards as is.

The key is to have your images in two places and packed separately from each other. I will usually have my images in three locations: the computer, the backup hard drive, and the memory cards themselves. I do not reuse the memory cards unless I absolutely must.

Your equipment can be replaced; your memories and images cannot. You will want to back up EVERYTHING each day or as much as time will allow! Keep your external drive in your suitcase and exposed memory cards in a waist belt. This way, you always have a backup on you and in another location.

Online backup may seem like a good option but can take too long to upload RAW images. Although most hotels do have wireless these days, the speed of that wireless can be extremely poor in many locations.

Backing up images is one of those things that we are constantly perplexed by. We tell our clients time and time again how often we see memory cards malfunction, hard drives and laptops crash, and cards get lost.

For some reason, many people feel like it will not happen to them. Yet, on EVERY tour I lead it happens to at least one person. Do yourself a favor and be prepared because you are investing a lot of resources to go on a trip. It would be a shame that your images do not make it back.

To clean cards, it is best to format your cards versus hit "delete." Formatting entirely cleans the card and leaves no hidden memory. Make sure cards are formatted and READY BEFORE arriving!

We cannot stress enough the importance of having enough memory cards and batteries. Your expensive camera only works as well as having a good battery and memory available.

Personally, I cannot imagine not having the ability to download, see my images, be able to back them up properly, and work on them while traveling. This is by no means something you have to do. But no matter what, if you do not have a system for downloading and backing up your memory cards, your images are at risk.

If you do not own a laptop, there are hard drives available that you can directly place your SD card into to back up the image files on it. Of course, you will not be able to work on or see your images, but they will be backed up, which is the key!

Photorec Toby, one of the leading photography gear reviewers on YouTube with over 163,000 subscribers, travels with us on photographic tours around the world and has this to say about memory cards and backup:

> One option if you want to leave the laptop at home is this—WD HD. This device allows you to back up a SD card without a computer. While it is a little slow, it does get the job done. Learn more or buy: http://amzn.to/1TjfLKB Note: this only works for SD cards. If you shoot with CF cards, there are no real options I can recommend at this time. If you buy it, take some time to use it before leaving for your trip to familiarize yourself with how it works. And please don't skimp on SD cards—recommended SD cards: http://amzn.to/1W4Yknp
>
> MAKE SURE YOU HAVE PLENTY!!!

Batteries and Charger

I recommend bringing at least three batteries that are FULLY charged before departing. If you are photographing in winter conditions, you will need even more as the cold more quickly drains battery life.

My experience has also been that it is worth the extra cost to purchase the name-brand batteries for a camera. They may cost a bit more, but the likelihood of their failing is far less, and they tend to last much longer than off-brand batteries.

Keep camera batteries in your carry-on. Do NOT store them in your camera in-flight as electronics at altitude can result in "dead pixels" in the camera's sensor. (I'll explain this issue more later in the book.)

10—Know Your Gear Before You Go!

One of the biggest mistakes you can make in travel photography is to not know or practice with your gear before you leave. As my wife and I lead photography tours all over the world, we do our very best to help our clients as much as possible to prepare before they ever set foot on an airplane.

This does not mean that we expect our clients to have it all figured out as far as manual settings, perfect composition, etc. After all, we pride our business in that we cater to mostly beginning to semi-serious amateur photographers versus the working pros.

However, with that said, I can tell you story after story of people joining us on tours who have never once taken their new tripod out of the box, for example. What then can happen is that when we arrive at some incredible location and need tripods out, rather than spending time helping them to understand the moment, create a beautiful image, and work on their photography, we are teaching them how to put a camera on the tripod. Meanwhile, the sun may have set, the light changed, and the moment passed by.

Now I do not mean to be insensitive here. I understand that we may need to tweak some things with our photographers and their gear, such as a tripod, while we are all out in the field. However, it is situations like this, where a person could have easily learned how to operate their tripod ahead of time, in the comfort of their own home, and been totally prepared for using their tripod—and getting that great shot.

This is what I mean by preparation. The same goes for knowing where your camera settings are, such as the shutter-speed dial and aperture dial. Once again, by no means do we expect the new photographer to understand all that comes with the manual settings. However, taking time to show someone where to change the shutter speed or aperture is something that the individual could have easily learned ahead of time.

Before you ever leave for a trip, you should become familiar with all of your gear ahead of time. That way you can learn without the stress of being out on location. And you don't have to worry about missing a great shot.

11—Manual Camera Settings

In my first book, *Photography Demystified—Your Guide to Gaining Creative Control and Taking Amazing Photographs*, the entire process of working in manual settings is described, in detail, with assignments to help you learn. Various cameras are discussed too. The entire book is to get you off of auto-mode and into full manual settings.

If you have not read that book as of yet, I highly recommend it, particularly if you are struggling with manual settings, depth of field, capturing action, and more. That book WILL take you from auto-mode to full manual settings.

http://bit.ly/photographydemystified

The reality is that in order to fully photograph at a level where you are in control and choosing what you want in an image, you must learn to shoot on manual settings.

When we are preparing our clients for a photography tour, we send them an entire tour packet. In it, we include the following quick quiz and overview of manual settings.

Quick Quiz

Without looking at your camera, what are the steps you need to take to change your camera's ISO sensitivity?

Spend extra time becoming familiar with all the controls on your camera at home, where it's nice and warm, before venturing out into your travels. In extreme situations, for instance, when you're wearing heavy gloves, it can be difficult to adjust your camera's settings. Knowing where your entire camera's controls are located helps you work quickly should you need to take off your gloves to make an adjustment.

Note to Our Clients Before a Tour

We know that many of you consider yourselves beginners. **Do not feel intimidated.** We are here to help and will be with you, instructing with our great staff. Please be familiar with your settings and tripod BEFORE the trip. This does not mean you need to know and understand everything, as you are there to learn; however, please know how to change your manual settings. The shutter speed, f-stop/aperture, and ISO are the settings to know how to change on your camera. Again, please know how to change those settings. This will help us a great deal in being able to instruct you on location.

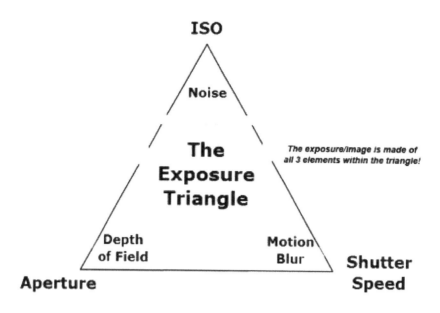

Manual Setting Overview

It is VERY important to understand that in any given situation, you will be using a combination of all three of the following manual settings: ISO, shutter speed, and f-stop/aperture. There are usually many combinations possible to get the same amount of light control; however, depending on what your preferences are to the character of the image, you may choose different ones at any given time.

This is why it is important for you to start becoming familiar with how to change each of the settings on your camera—*now*, as in, *before* leaving on the trip. With these manual settings, we will be able to help you get the most out of your camera.

ISO—Light Sensitivity

Think of ISO as what you used to do with film. You would go to the film store and choose the speed of film you wanted. In today's digital environment, we have the flexibility to be able to change our ISO in each shot if we want. This gives us much more power than in previous film-camera days when we were stuck with whatever we'd put in the camera.

The LOWER the ISO, such as 100 or 200, the BETTER the quality of the final image, but MORE light is needed. Light can be available through ambient light (natural light) OR the use of a flash. Higher ISO speeds, such as 1600 and above, result in a loss of image quality and "noise" in the image. However, the higher ISO may be needed in order to use faster shutter speeds in lower light situations and when a tripod may not be available.

Thank goodness we no longer have to take rolls and rolls of film with us on a trip! Not only was it expensive, it also had to be handled precisely if going through an X-ray, and in today's security environment, that is almost impossible.

Then, by the time we arrived back home, off we would go to the local one-hour photo, simply hoping our pictures looked good! Digital has changed the game, for sure!

Shutter Speed

Shutter speed refers to a <u>time value</u> represented by the amount of TIME the shutter opens and closes to allow light on the sensor. The LONGER the shutter speed setting, the MORE light comes into the sensor. Yet motion is not stopped. The FASTER the shutter speed setting, the LESS light comes in, but action can be stopped.

A fast shutter stops action, a slow shutter allows motion. Never hand-hold the camera in a setting under 1/60th of a second. This usually results in blurry images because of "camera shake." However, this "rule" is also based on the length of lens you are using.

Shutter Speed Scale

This symbol that looks like a quote denotes you are in seconds

30" 15" 10" 5" 3" 1" 1/2 1/4 1/8 1/15 1/30 1/60 1/125 1/250 1/500 1/1000 1/2000 1/4000

Slow Shutter slows motion
lets MORE light in

USE TRIPOD
under 1/60th

Fast Shutter stops motion
lets LESS light in

Aperture, F-stop, Iris

These three terms are all for the same item. Your f-stop setting controls how much light comes into the sensor through the opening of the lens. The SMALLER the number f-stop, the MORE light comes in. The LARGER the number f-stop, the LESS light comes in. Think of the aperture like an eye. When you are in a dark setting, you may need a bigger opening (just like the pupil of an eye). The opposite is true in a bright setting.

F-stop also controls depth of field. The smaller the number of f-stop means a shallow depth of field. The higher the number, the greater the depth of field will be in your image.

Aperture openings in a typical lens

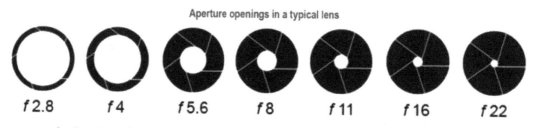

f 2.8 f 4 f 5.6 f 8 f 11 f 16 f 22

Small numbers allow MORE light
Small numbers have LESS Depth of Field

Large numbers allow LESS light
Large numbers have MORE Depth of Field

12—Packing Tips

It is my personal opinion, that packing is an art form! My wife, Ally, has taken it to a new level. Although I am the one writing this book, she is the one that has made this section possible. Ally has learned to pack everything, and I mean everything, we need. She has learned to pack right to the very limits of weight yet keep everything totally organized and ready to go from hotel to hotel, night after night.

This includes bringing a small coffee press, so I can have great coffee each morning!

Luggage

Lightweight luggage can save you anywhere from 3 to 10 lbs.! We have two we love, Revo (Swift or Switch) and IT (world's lightest two-wheel). The Revo has thicker outside cushion walls than the IT, which has thin, strong fabric with no cushioning.

We love www.ebags.com, which offers free, prompt delivery and regularly has 60% or more off manufacturers' suggested retail prices. We have also found these brands at Ross-type stores but availability is hit or miss.

Check with your airline carrier to find out bag weight and size limits!

>28- to 29-inch large

>25- to 26-inch medium

>20- to 22-inch small (carry-on)

Packing the Bags

When it comes to keeping all of your clothing and items organized, individually packed bags that go in the main luggage bag are the way to go. As an added benefit, they help keep your clothing from getting wrinkles. We use these to keep everything separated within our luggage, so it is all quite easy to get to and well-organized.

You can also find these online as well as in any luggage or travel store.

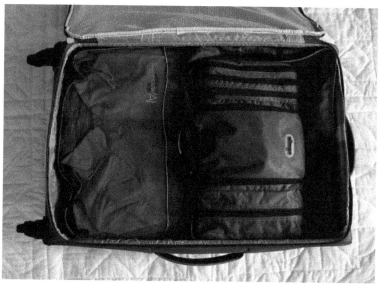

Shoe bag

Clothing

Shoes are the most important item you need. Do not take new shoes! Daytime shoes should be durable for damp cobblestones, rough surfaces, and stone walkways (rubber soles are good). Vanity should be replaced with practicality. You might opt for soft leather shoes that are less bulky. Waterproof hiking-type shoes are always an excellent choice!

Daywear should be comfortable and casual. "Safari"-type pants are easy and light. Dark colors, plaids, and wrinkle-free fabrics are best in things you can mix and match and wear more than once. You are highly discouraged from clothes (t-shirts) with any kind of "American" or "USA" slogans, boasting you are from the USA.

Leave your flashy or expensive jewelry at home. Don't take anything you cannot afford to lose! Take costume jewelry if you want to have accessories, including watches.

Rule of thumb: Take half the clothes and twice the money you think you'll need, and you will be fine!

Lightweight layers are the most versatile. Always bring a lightweight waterproof jacket. It is possible to easily handwash lightweight clothing and hang it dry in a hotel. Some hotels may offer a laundry service.

Quick-drying specialty clothing and underwear, such as the ExOfficio brand, are amazing and will dry within an hour. Brands, such as Kuhl, Columbia, and REI, all have shirts and pants made with specifics to be lightweight and easy to wash and dry.

Laundry On the Go!

Most hotels offer laundry service. However, as you can imagine, it can be quite expensive. In some cases you may find your hotel or local area has facilities where you can do the laundry yourself. However, more often than not, this will not be the case.

The other situation is that many hotels do not have a bathtub or a washbasin that is large enough to put your clothes in for handwashing. With all this and all of the traveling we do, Ally has created the "laundry-on-the-go" system that works awesome.

I have to admit, without Ally, I would have never figured a lot of this stuff out!

Here is Ally's laundry-on-the-go system:

1. Take a large Ziploc bag and use that as your washbasin.

2. Place your clothes in the bag with some detergent.

3. Use the showerhead to fill the bag with water and wash the clothes by shaking the bag and massaging the clothes inside it. Then rinse your clothing.

4. Ring dry by hand.

5. This is KEY: Bring TWO microfiber towels. Lay one down flat on the floor. Now place your washed clothes on the first towel and place the second microfiber towel on top, so your clothing is between them.

6. Walk on the towels and your clothes, and the towels will soak up most of the remaining moisture from the clothes.

7. Hang dry and leave fan on.

The one item to note is that if you have quick-drying clothing and underwear, such as ExOfficio, as an example, your clothes can be totally dry in about two hours.

If the climate is humid where you are at, this, of course, can change that. We always try to do laundry where we are staying for at least two nights just to make sure we have plenty of time for it to dry adequately.

Cords and Adaptors

Most countries outside of the United States operate electrical appliances on 220 to 250 volts. In order to operate your appliances, a correct plug and travel adapter will be needed. Outlets for small North American appliances operating on 110 volts are sometimes supplied in leading hotel chains.

You will need a special adaptor, that your plug fits into, to insert into the outlet because the outlets are different than those in the US. You insert the plug into the adaptor and then insert the adapter into the outlet. If you have equipment that has a switch to 220 (dual voltage), you still need the special adaptor for the wall socket.

Travel adapter kits can be purchased at many stores. There is no need for the transformer. Just the adaptor is all you will need for most electronic devices. It is suggested that you operate hair dryers and curling irons on low, so they don't burn out. Most hotels have hair dryers in the rooms or can at least offer you one to use.

Ally and I have found it very useful to bring a small extension cord and/or wall plug with more than one outlet, as well as USB ports, that we plug into the adaptor for the country we are in. In this way, we can operate more than one electronic device but not have to carry a bunch of adaptor plugs.

It is also a good idea to have a surge protector when charging any expensive electronics, such as a laptop, in countries that are not well developed. This can also be said if you are in small towns or older hotels in the USA or developed countries as well.

Arranging Your Luggage and Theft While Flying

Unfortunately, due to the fact that we have seen luggage opened and items "lost" on trips while flying, Ally has developed an excellent method to help deter theft of things inside a bag. We tend to see this more from the baggage handlers in countries that are a bit underdeveloped, but we have even seen this from American baggage handlers too.

The first thing to keep in mind is to make your luggage less of an easy target than other luggage. By simply creating some work for someone that wants to "check" your bag, you are causing them more time and hassle than they want to spend, and they will move on to the next bag in many cases. I recommend having TSA locks on your bags to help deter opening as well.

First, make sure any electronic devices, including cords and adaptors, are _not_ placed on top. These items seem to easily go missing from bags when they are in plain view and easily accessible, right as a piece of luggage is opened. These tend to be targets more than most other items. Shoes seem to be second, so do the same with those.

Next, take the large sealable plastic bag that you are taking for laundry and place all of you individual travel bags with in it. Place each individual pack bag with the zippers and opening down.

Last, if you like to take your own pillow (I always take a pillow), place it on top as it is one more item that has to be taken out to get to the "good stuff" in your bag.

As the bags come off the plane and are loaded and handled, if your bag is opened by someone looking for an easy "catch," the hassle of taking this entire situation out is usually more than enough to be a deterrent, and they move on. They do not have time to deal with this along with the risk of being caught or seen.

Luggage Weight

By now, anyone that has flown in the last several years should know that there are weight limits on checked luggage and sometimes even a carry-on as noted above.

So, why is it every time I go to the airport, which is at least once a month, I see people with their clothes and belongings all over the floor trying to adjust their bags for weight?

People should know by now that when an airline says 50 lbs., they mean 50 lbs.! This is one of those pet peeves of mine. You should KNOW the weight limit of your checked bags for your airline and weigh it ahead of time! If you are close, realize that the scales tend to favor the airline and not the passenger, and re-think your luggage.

If you must bring everything you have, it is usually far less expensive to just check another bag than to be overweight. This is also another advantage to being a member of a frequent flier program, having the airline credit card, and gaining status.

Climate

Check the weather a couple weeks prior to travel and again every 3 to 4 days to see the trend. Weather is always unpredictable, so be prepared. Even if the weather seems pleasant when you are about to travel, you know it can change, so it is always best to be prepared! Have a good rain-protective, hooded lightweight jacket and a pair of waterproof, hiking-style shoes.

13—Suggested Travel Checklist

Gear

- Camera(s)

- Lenses

- Tripod and plate that attaches to the camera. Extra plate advised as well.

- Memory cards (formatted with no images)

- Camera batteries

- Battery charger

- Camera bag

- Small bag (Think Tank TurnStyle)

- Plug adaptor, appropriate for countries visiting

- Notepad and pen

- Small, light flashlight

- Laptop and small, lightweight external hard drive

Clothes

- Lightweight travel clothes are best. (Layers and warmer items can be good too, depending on where you are going and when you are going there.)

- Hat

- Gloves you can shoot in, if winter conditions exist. (Gore-Tex thin gloves are great. REI has them.)

- Lightweight jacket

- Heavier jacket (Check weather if needed)

- Comfortable shoes! A MUST and worth the money!

- Swimsuit (for beach or hotel with pools and hot tubs)

- Thermal underlayers (check weather)

Miscellaneous

- Suitcase

 Weight not in excess of 50 lbs. internationally (44 lbs. for inter-island flights, etc.). Check with your carrier! If you are over, it does cost. You can pre-purchase extra weight and luggage at a reduced rate.

- Travel locks, TSA-approved

- Airline tickets and confirmation numbers for <u>all itineraries</u>

- Passport (Make copies to leave at home with family. Bring a copy with you too.)

- Driver's license/ forms of ID

- Travel insurance and policy

- Keep copy of hotel locations on you at all times, in case you need to show a taxi driver.

- International phone plan arrangements

- Phone and charger

- Money belt

- Some money exchanged ahead of time! (Travel Ex, your local bank, or at the airport exchange center)

- Credit card company contact info

 Notify your credit card company of your travel dates and locations, so they do not shut your card down when they see charges on it from an international or very distant location.

- Emergency contact numbers

- Needed medications, pain relievers, vitamins, etc.

- Motion sickness medicine

- Lightweight travel towel

- Toiletries

- Laundry soap for handwashing

- Sunscreen

- Sunglasses

- Jacket/Coat/Gloves

- Chapstick

- Earplugs

- Hand sanitizer

At Home

- Pets cared for

- Copies of passport, visa, and where you will be staying, so others can reach you in case of an emergency

14—Tips for Air Travel

Batteries, Flying, and Dead Pixels

Here is a tip about carrying your cameras on the plane. It is something we have personally experienced and want you to avoid! The issue I speak of is known as "dead pixels."

Here is what happens: When you are flying above 20 thousand feet, the air is thinner and electronics are not as protected from the gamma rays as they are when down on the ground. This is why camera manufacturers ship their cameras via ship.

These gamma rays do not hurt us, but what is happening is that the gamma rays induce voltage into devices' sensors that literally fry pixels. They result in your image having a "missing" spot. If you are really unfortunate, the sensor could actually fry an entire row of pixels, resulting in something similar to what a scratch on a negative would look like back when shooting film.

The solution is simply to make sure your batteries are not in your system while flying. Due to the possibility that batteries could explode, they are also not allowed to be checked in your luggage. So simply carry them on with you with your camera gear but not in the camera, and you will be in good shape!

Packing Your Gear

As previously mentioned, I personally love my Think Tank Airport Roller Derby camera bag. This bag allows me to carry pretty much anything I will need on a photography trip, all while having the comfort of rolling it along as I scramble through an airport. This bag also includes a laptop compartment.

As you can see in the image below, my bag in this instance has two camera bodies, a wide-angle 16–35mm lens, a medium range 24–105mm lens, a 70–200mm telephoto lens, and a 150–600mm telephoto lens!

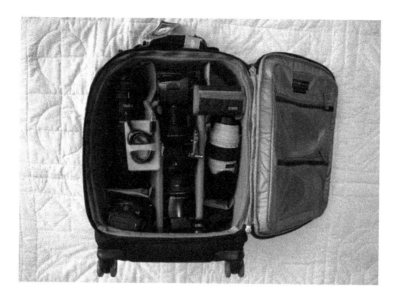

On top of all that, there is plenty of room for an extra hard drive, batteries, lens cloths, memory cards, and much more, including space for the laptop. All this fits in a bag that satisfies all regulations for size requirements when flying.

For those instances when I prefer to bring a large backpack instead, I use the Think Tank StreetWalker HardDrive camera bag.

Be sure that when packing your bag, your batteries are out of the cameras as mentioned earlier. Be sure that all of your gear is in well-padded compartments and that all of your lens caps, filters, and items are secure.

Once again, if for any reason you must gate check your cameras and gear, if on a small plane, for a portion of your trip, take out your laptop and batteries.

Remember, I always ask the luggage handler taking my luggage to please make sure it is not thrown, and if on a return flight from a trip, I take out my memory cards with images on them and keep them with me as well.

> **TIP:** A roller bag is considered a carry-on, and a backpack is considered a personal item. In most instances, you are allowed both a carry-on and a personal item, so this is a way to take more with you on board. (Check your airlines to make sure this hold true.) If you need to pack some extra gear or items, use both. A medium-sized camera backpack will suffice as a personal item, just like a purse or small bag would.

Carry-on Items

The difference between a comfortable flight or being miserable can come down to how and what you carry on with you. It can also help prevent illness.

There are a few items that I consider a must on all long flights. Besides the obvious of bringing your gear on board, make sure you are set to be as comfortable as possible. This includes a flight pillow, your own earphones, a power adaptor if international, a toothbrush with built-in paste, and sanitizing elements.

Did you know that most flights only have 7 to 8 minutes to be "cleaned" between turnarounds? With this in mind, as gross as it may sound, chances are that the tray table you are eating off of is filled with bacteria. The seat pockets in front of you—yep, those as well.

It only takes one flight with a dirty diaper in the seatback in front of you or a child with snot coming out of his nose playing on the tray table for you to realize you'd better take me seriously. Tray tables are not wiped down in the turnarounds, only in overnight status, and then it is marginal at best. Studies have shown tray tables to be some of the most contaminated parts of an aircraft. Can you say, "Ewwwww"?

The last thing you want is to get sick on your trip. Every flight I am on, I wipe down my tray table with disinfecting hand wipes. I make sure to not only wash my hands but use hand sanitizer as well. Last, I will always wipe down my phone after a flight too.

Jetlag and Medications

To avoid jetlag, stay well hydrated on the plane, and avoid alcohol. Getting up, stretching, and muscle flexing exercises can help circulation. Some people find it helpful to bring sleeping pills for the longest flights.

Choosing an aisle seat on long portions of a flight is much better than a window for the sake of being able to get up as you want and need to.

Pick-me-ups can be helpful, such as vitamin B. Drink mixes, like Zipfizz, Emergen-C, Airborne, and No-Jet-Lag tablets, can be good to have handy as well. Some people experience constipation after long flights, so you may want to bring along something for that as well.

Some simple behavioral adjustments before, during, and after arrival at your destination can help minimize some of the side effects of jet lag.

- Select a flight that allows early evening arrival and stay up until 10 pm local time. (If you must sleep during the day, take a short nap in the early afternoon, but no longer than two hours. Set an alarm to be sure not to oversleep.)

- Anticipate the time change for trips by getting up and going to bed earlier several days prior to an eastward trip and later for a westward trip.

- Upon boarding the plane, change your watch to the destination's time zone.

- Avoid alcohol or caffeine at least three to four hours before bedtime. Both act as "stimulants" and prevent sleep.

> **TIP:** MAKE SURE you have ALL NEEDED medications with you on your flight. If your luggage is delayed for any reason, then it won't be a problem because you'll have your medications! Make sure to pack any medications for stress/anxiety as well if you are a person that needs that.

Part Three

Your Trip Has Begun!

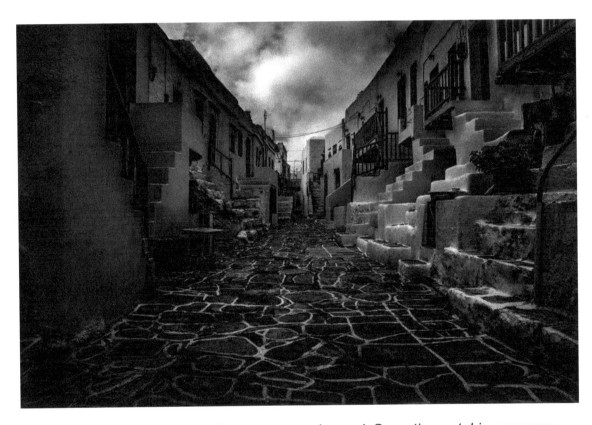

You cannot expect everything to go as planned. Sometimes, taking a wrong turn leads to an image and location you would have never seen—almost as if the image was waiting for you personally. This is what happened above while on the island Folegandros in Greece.

15—Practical Advice

Safety/Security

Simple tips, such as using twist ties to close zippers and luggage locks when leaving luggage at hotel room or holding area, can help deter potential theft issues. Twist ties cannot be on when you check your bag, unless it is a TSA approved travel lock, but can be a theft deterrent once you are out of the airport. A travel lock or twist tie is also a good idea for your camera bag too. It may take an extra moment to get a lens out, as an example, but that is better than a stolen lens!

If you are handy with a sewing machine or needle and thread, you can sew waist wallets or passport neck pockets into clothing.

If you are like us and want to travel more lightweight, just be smart, use common sense, and be diligent about your safety and gear. As is true in the US, there are people out for tourists in touristy areas.

Based on experience and common sense, we recommend a waist wallet or ankle wallet for your passport and the cash that you won't be spending that day. You can also go to a bank and get cash every few days; however, availability and location of banks could be an issue. Travelers cheques are obsolete.

You can check with your bank for networks that your debit card will work on. It is recommended to not use your debit card for purchases and only for ATM/bank withdrawals.

When I leave the hotel room, I make sure nothing expensive is in plain sight or tempting. I recommend putting your laptop and any other gear you leave behind into your suitcase with a TSA lock on it. In all my years of traveling, I have never had an issue when doing this.

If your hotel has an in-room safe, that is also an option for extra money, your passport, and any other small expensive items you do not want with you while out. Be sure to ALWAYS do a complete walkthrough prior to leaving your room for another location as it is easy to lose and forget your items in the safe!

Credit and Debit Cards

Credit cards are safe, convenient, and generally offer good exchange rates. Note, however, that many—but not all—banks now assess a 1% to 3% "foreign transaction fee" on all charges you incur abroad.

I recommend using credit cards and cash for spending. I typically recommend having $300 to $400 dollars with you at the start of a trip. But whatever you are comfortable with is the way to go. Try to use your card when possible and use cash if preferred.

I always have at least two credit cards available. In case for any reason a card does not work, I have a backup. My wife and I have both had our cards hacked a number of times while traveling, so it is good to be prepared.

> **TIP:** You need to let your bank and credit card company know where you will be traveling, so they don't think any charges from a distant or foreign location are fraud. It is a good idea to bring your credit card company's phone number along as well.

Phone

You will want to turn off "roaming" on your cell phone. Otherwise, you will have a HUGE cell phone bill! Do NOT USE the hotel phone for international calls, as it is EXTREMELY expensive. The best thing to do if you need to communicate with home is to use email, Skype, Facebook, etc.

Check with your carrier about international plans you can get for just a month. It usually saves you a bit, and texting costs less than a phone call, typically around 50 cents per text. The best advice is to have your phone off, as you DO pay for texts that come in as well!

SIM Cards

An excellent option to consider for using data abroad is to purchase a SIM card from a reputable company, like Vodafone, upon landing. Simply purchase the card at a store that you can usually find in the airport or city you are visiting, and exchange the SIM card out in your mobile device. Personally, this has been the best option we have found in order to get excellent coverage and data usage at an extremely affordable price.

Internet

Most countries will have available Wi-Fi in hotels. I have found that even in remote areas, you can usually get signal. However, I highly recommend using caution if you are doing any type of banking or online activity that involves secure data on hotel Wi-Fi. Although you may be told it is secure, we personally have experienced security issues, honestly, more in the US than abroad.

With this in mind, it is a great idea to rent a personal Internet device. These devices can be rented with various data plans. As long as there is cell coverage, these devices allow you a secure network and the ability to have Internet at all times while on the go.

Language and Culture

You will find that English is spoken in many areas around the world. It is nice to try to learn a few words in the language of the countries you are visiting. *Hello, good-bye, thank you*, etc., are nice to know. You may want a small pocket dictionary or app to refer to. You might want to know the meaning of words along the way or to help in menu reading (most places do have English menus).

Please respect the customs and traditions of the places you visit and be appreciative of any help you are given. BE FLEXIBLE—you are traveling to learn and experience new things about other cultures, NOT TO CONVERT THE WORLD to the American way! It is exciting and fun to experience things differently from our regular lives at home.

> *Travel teaches toleration.*
>
> —Benjamin Disraeli, 1804–1881

Language Apps

There are a variety of inexpensive or even free apps available to help with language. One of the best is Bravolol. What I love about this app is that it will actually pronounce out loud what you are trying to say.

For instance, in Swahili, the word for water is *magi*, but the word for poop (s%*t) is *mavi*. One of our instructors asked for *mavi* one time, instead of *magi*, at lunch. Of course, we all had a good laugh and so did the waiter! As you can see, it is good to make sure you get the words and pronunciation correct!

Another great thing about this app is that you do not need to be connected to the Internet to use it. This is very helpful for when you are out roaming around and may need to ask someone a question or seek help.

Features of the Bravolo app include:

- commonly used phrases and vocabularies

- font-size adjustment

- authentic pronunciation

- pronunciation—recording yours and comparing it

- favorite phrases—storing and managing

- keyword search of phrases and vocabulary

- Internet connection not required

Google Translate is free and also very helpful. Features, such as being able to tap the camera icon and point at a sign for translation, can be particularly useful.

With the Google app, you can speak, type, or draw characters on your smart phone and the app will translate what you are trying to say or understand.

With all this technology available, it can prove to be easier, however, to remember that there is no substitute for learning a language or some vocabulary, which will show the locals you are making an effort and also which will allow you more of an authentic experience in culture.

> **TIP:** Learn your app ahead of time. There is no use trying to figure it out while you are looking for a restroom.

Passport Control

DO NOT FORGET YOUR PASSPORT as well as other forms of ID. Make copies of these as well as emergency contact info to leave with relatives. Also have copies with you when you travel in case your passport or ID get lost or stolen. Have copies of your trip insurance papers with you as well.

It is HIGHLY recommended you keep a copy of your hotel/accommodation names and addresses on you at all times while traveling. If you get lost, all you have to do is get a taxi and show them the address.

You MAY be REQUIRED to hand over your passport at a hotel. This is common in some countries but not all, and the laws change. Please do not fret if asked.

You will go through passport control on arrival at the destination airport. Have your passport ready to show the official. If you are making a flight connection in a European city and get outside the secured area, you will go through passport control again and have to show your flight ticket to reenter. You do not "go through customs" until you arrive back to your first point of entry into the USA.

When you arrive in another country, you will pass through the area that says "nothing to declare." You will receive a declaration card on the return flight, and it will be presented to customs on arrival in the USA.

If you intend on making expensive purchases (jewelry, electronics) or have other questions, it is best to view www.customs.gov for information in regards to taxes and customs rules.

16—Be a Tourist

Our happiest moments as tourists always seem to come when we stumble upon one thing while in pursuit of something else.

—Lawrence Block

When I say, "Be a tourist," I am sure visions of flowery Hawaiian shirts, knee-high socks, shorts pulled up past the belly button, and the words "I'm American and Proud" on a hat, along with an attached fanny pack, come to mind. This is NOT what I mean!

I always love to mix touristy items in with my photography tours. After all, who can go to Florence and not see Michelangelo's David? My point here is that it is okay to be a tourist. In reality, that is what you are, and it is okay to be one!

On some photography tours, I have witnessed people get into the mindset of "I don't want to do touristy things. I am here to shoot." When I ask them what they want, their visions of early morning sunrise shoots and evenings at the golden hour come up. It is usually at that point that I will ask about the wonderful known sites in some of the locations we may be visiting.

As an example, in Athens, Greece, there is the Parthenon. This is the most visited site in all of Greece and one of the most in the entire world. On any given day, there are literally hundreds of thousands of tourists. So I may ask, "What about the Parthenon? Do you really want to come all the way to Greece and not see it? It is not open at sunrise, so we have to go during operating hours, so it will be busy, but would you rather not go?"

Usually I get a response of "Well, that's different." Yet in reality it is not. In every major city across the world, there will be "touristy" things to do and see and photograph. Granted, these may not be your most stunning images, but to travel and not see some of the so-called tourist hotspots is doing a disservice to yourself.

Remember what I said—traveler first, photographer second. You must have an appreciation for the locations you are visiting. Sometimes they are rich in history and culture, and these spots may just be the tourist hotspots. Take them in!

I personally think that some photographers just see themselves as so serious and have visions of being the next National Geographic photographer that they lose sight of the experience of travel, which can and should include being a tourist!

17—Get Lost

Half the fun of the travel is the esthetic of lostness.

—Ray Bradbury

Yep, get lost!

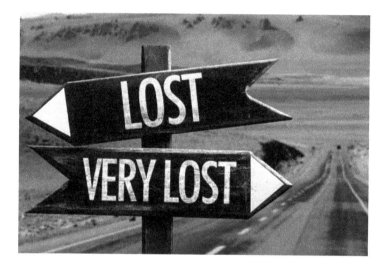

Let me give you an example of what I mean. Let's take Venice since I mentioned it already.

Venice is a location that people from all over the world visit and often they plan out every detail of their time there. There is so much to see in Venice, with St. Mark's Square (Piazza San Marco) being a highlight, that so many tour groups come into the city via cruise ships that it can get totally packed with people.

I am always amazed at how so many people get off a cruise ship, spend five hours in a city, get their t-shirts, and then have to get back on the cruise ship and do it all over again the next day in another location. This is not for you!

A city like Venice is the perfect city to get "lost" in. If you simply start walking, you WILL get lost, and it is awesome! You will find yourself walking down alleyways barely wide enough to get through. You will come across local ladies and gentleman having cappuccinos and walking their dogs.

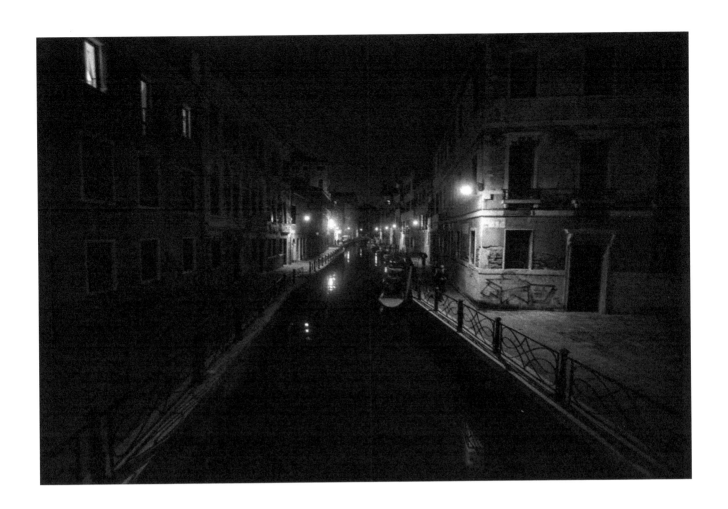

Every turn and corner will afford you interesting photographic opportunities that most "tourists" never see. You will take your time and experience the beauty and culture of Venice in a way that is very special. This will "feed" into your images. Your photographs will contain life and emotion rather than just more tourist shots!

Once the crowds and cruise ships are gone, that is your time to go explore the locations that are filled with thousands of people during the day. I have literally been in St Mark's Square all alone at 5:30 am or 11:30 at night. This is quite a different feeling and photographic opportunity as opposed to 1 pm in the middle of the day with 50,000 people in the square.

If you are lost, the beauty of Venice is that you just keep walking and eventually you will come to a waterway where you simply get back on the Vaporetto (water bus) and make your way back.

I take this same approach anywhere I go in the world. I try to get "lost" at least once. Of course, you want to be safe, use common sense, and not be alone in certain situations or locations, and it is always good to have a travel buddy with you.

To get back to my hotel, I simply take a taxi. Yes, I may get ripped off a bit on the fare, but it sure avoids taking the bus and not knowing where to get off!

18—Chase Light

In my second book, *Photography Demystified—Your Guide to Exploring Light and Creative Ideas*, I wrote extensively about the various qualities of light and how to photograph it.

Hopefully, you have already read through that book as well as my first. Together, those two books provide a solid foundation for controlling all of the elements in regard to exposure and how to recognize and photograph various qualities of light, including various scenes.

The single most important factor to photography is not your gear. It is your ability to recognize and photograph great light!

Here is an excerpt from my second book:

> Photography is all about light. It has always been about light. In fact, the very meaning of the word "photography" means "to draw with light"! I like to use the term "painting" with light. We, as photographers, are in essence harnessing light, using it to reflect off of a subject and record to our sensor or film. We are in the very real sense of the word, painting with light. Without light, we do not have photography.
>
> As light is truly the essence of photography, it is important we take time to explore light. Before I get into specific subjects and the how-to of those subjects, I want to set the correct foundation. As in my first book, you know that the foundation is the key to a great image. I

am not one that cares for the attitude and mindset in photography that is of "let's shoot it and fix it later."

We are going to start with various types of light and how you need to pay attention and PLAN for the images you want to attain by always considering light. As you continue on your photographic journey, NOTHING becomes more important than the light you are photographing in. Neither your fancy equipment nor your post-production skills in Lightroom or Photoshop will do for you what the best light does when it comes to photography. Sure, those items might help, but realize, it is NOT the camera that makes a great photograph; it is the person behind it. Without the best light, your photography will not be what it can be.

You can get your copy of *Photography Demystified—Your Guide to Exploring Light and Creative Ideas* here. http://amzn.to/1VxZUy7

With this in mind, after all of your preparation, the single most important aspect to creating great travel photographs will be recognizing and chasing light. This is where everything you have learned photographically in the previous books, as well as on your own or with other educators, comes into play.

Mendocino, CA

This may mean that you have to get up before dawn to catch the amazing twilight and ensuing sunrise that follows. Or, it may mean that you stay out late to capture the evening mood of a city

after dark. Whatever it is for you at that moment, it is important you chase after great light as you see it happening.

This may mean that your plan to go left now takes you right, or your plan to shoot at one location all of a sudden changes. This is where you learn to recognize the quality of light, what is happening, and act on it. You MUST be flexible. In fact, we tell all of our clients on our tours that the single, number one factor to enjoying the trip is to be flexible. Yes, I've shared this already with you in this book—but I cannot urge you enough to take it to heart—be flexible. This is because things WILL change, and the unexpected will happen with light. As we recognize it, we chase after it!

Chasing light means being willing to alter your plans and go for the shot. Sometimes, I even feel a bit like one of those storm chasers you see on television when they are filming and trying to catch the tornado. Although not as drastic and far less dangerous, it is that same mindset of adrenaline rush and go-get-it attitude that will take your images to another level.

Keep in mind, if you are traveling with others that are not into photography, this presents a problem. This is another reason to consider a photography-based tour as everyone wants to go out and shoot!

19—Use a Variety of Lens Focal Lengths

As I mentioned earlier, if you were to ask ten photographers about necessary gear or lenses to take on a trip, you may very well get ten different answers. The truth is, that there is no one lens for everything and every subject that you may want to photograph.

The other truth is that everyone "sees" differently, and you may be a person that likes the small details in a scene while another may be a person that likes the entire scene. You may not even be sure exactly what it is you like and, therefore, need to experiment more.

The choice of what lens and focal length to use should be based on the distinct perspectives a particular lens creates, NOT on whether you can get closer or farther away from a subject with it!

Wide-angle lenses make the foreground elements appear larger and the background elements appear smaller. This gives much more emphasis to the foreground and makes the background appear smaller. This distortion of perspective from the lens causes the background elements to appear as if they are far away from the foreground elements, even though, in reality, they are only a few feet apart. Therefore, the misconception of depth is in the scene.

Telephoto lenses do the opposite. They make the background appear larger in comparison to the foreground. These lenses compress the perspective, making objects that are actually quite far apart appear as if they are close together.

I want to suggest that no matter how much you like a certain lens or focal length, or find yourself most comfortable with a certain way to shoot; you actually push yourself to do something different.

This is true even for me. In fact, recently, I was leading a tour with our team to Moab, Utah. I have photographed in Moab many times, and it is one of my favorite locations in the US because of its incredible landscape, color, and rock formations.

Many times in the past few years, I have ventured into Arches National Park and found myself staring up underneath amazing formations and using my wide-angle to create awesome images with a unique perspective that many never really do the work to get.

On this trip, however, I was challenged by my good friends Toby of photorec.tv and Adam Furtado of photonerdsunite.com. Adam especially loves to shoot longer lenses and pick parts of a scene and is he is very good at it.

They had recently done a video on Toby's YouTube channel about shooting landscapes with long telephoto lenses. I must admit, I rarely use a telephoto for my landscapes, as I always love shooting a wide-angle lens. On the other hand, Toby has often stated that a medium overall focal length of 24 mm or so is plenty wide enough for most scenes, to which I always respond, "No it's not."

On this last tour, I decided to really challenge myself to something different. I not only decided to use a long telephoto, but I decided to use an extremely long telephoto. I approached many of my landscape images using my 150–600mm and shot many of the images between 400 mm and 600 mm in focal length! This is the same lens I use for wildlife primarily, but here I was using it for landscape images. Below, I will show you some examples and how I went about this challenge.

Conversely, when Toby found himself inside double arch, he walked out, declaring, "Thanks for letting me use your wide angle lens, David. I really needed a wide-angle lens as it really showed a different perspective than I'm used to."

My point with this is that as photographers, we should challenge ourselves to try new things, find perspectives, and "see" differently than we are used to. By trying a variety of lenses, you will find it creates situations where you have to move yourself either closer or farther away from your subject to get what you want.

That brings me back to my other points from earlier in the book about what gear to bring. The reality is, if gear were light, I would recommend bringing it all. For me, if I am going to do a ton of walking, I probably am not going to carry that 150–600mm lens around. Yet, in this case in Moab, I was able to grab it right out of my vehicle and shoot some magnificent images right from the road.

When all is said and done, choosing what gear to bring really becomes a matter of personal choice and perspective. Adam and Chris from photonerdsunite.com, two of our instructors, will carry their entire camera bags around with them at all times and then choose as they go what they want to use. This, of course, gives them many more options for lens choice, no matter what they encounter to photograph.

On the other hand, I try to simplify and not carry too much. For me, I choose what lenses I think I may need for a location. This is because I really do not feel like lugging tons of gear around if I can avoid it.

For instance, if I am walking the streets of Cuba as I just did recently, I really want to be mobile, quick, and able to just photograph the street life on the move. If I am carrying all my gear, for myself, I do not feel I can capture the moments and life of the streets as it is happening. Sure, there will be times I wish I had another lens on me in certain situations, but the reality is, I have to choose what works best for me and how I choose to shoot.

On the other hand, if I am doing landscape photography and am able to access my gear quickly in a vehicle, or just have to carry it a short distance, I will bring everything I have. In this way I can choose whatever lens I want at any given time in any situation.

The reality is, you have to look at each situation, and as you grow as a photographer, you will start finding what works for you.

Let's take a look now at various lenses and some effective ways to use specific focal lengths. As you learn your lenses and what they do, you will come to understand what you like and how you like to shoot. Lenses are also covered in great detail in my first book in the *Photography Demystified* series.

20—Wide-Angle Lens

I notice that many beginning photographers like to just zoom in on their subjects leaving no room for the journey to the subject. One of the reasons I love photographing certain situations with a wide-angle lens is that it allows the viewer to "walk into a scene," so to speak.

The viewer was probably not there when you photographed. The viewer didn't see it or feel it exactly as you may have. One of the struggles in photography is how to take a two-dimensional medium and help the viewer feel as though they can move into what was a three-dimensional scene in real life that you experienced.

As I travel the world, I continue using my wide-angle lens a considerable amount of the time as I explore back alleyways, hidden gems off the beaten path, and scenes of everyday life in cities.

I also will use my wide-angle lens to create a different perspective than most people are used to seeing. I will do this by either getting extremely close to a subject so that the perspective is thrown off because of the way a wide-angle lens distorts in the corners of the resulting image, or I show more of the area around and leading into the subject, thus allowing the viewer to "walk into the scene." Sometimes, both elements are in place.

What I will not do is use a wide-angle lens just to get more "stuff" in my image. You will notice in my images that I am very selective about the subject matter. It is not just about getting "more" in an image, but rather about changing the perspective in regard to the subject I am photographing. This will also allow the viewer to have a different, unique perspective of what they are seeing.

Take a look below at the various visual samples I have included in how I tend to use a wide-angle lens. These visuals and explanations will help you understand the use of these types of techniques discussed and how to get the most out of your wide-angle lens.

Foreground

When using a wide-angle lens, as you are getting more of a scene, it is important that you make sure you have an interesting foreground. Otherwise, there can be too much "dead space" or "cluttered space" in the image.

By using an interesting and complimentary foreground and making sure it adds elements of perspective and compositional guidance to the viewer, it will help the viewer take what I call a "visual journey" through your image and into your subject.

This can also help naturally frame your subject nicely and give a sense of depth to the image.

As an example, look at this image below. This was taken while leading a photography tour on the set of *The Hobbit*.

Notice the use of the foreground and the way the line of the pathway and point of the foreground hedge converge and point you directly at the main subject, which is a hobbit house located at "Hobbiton" in New Zealand.

In this image below taken on Lake Obersee in the Bavarian Alps, notice the use of the foreground once again.

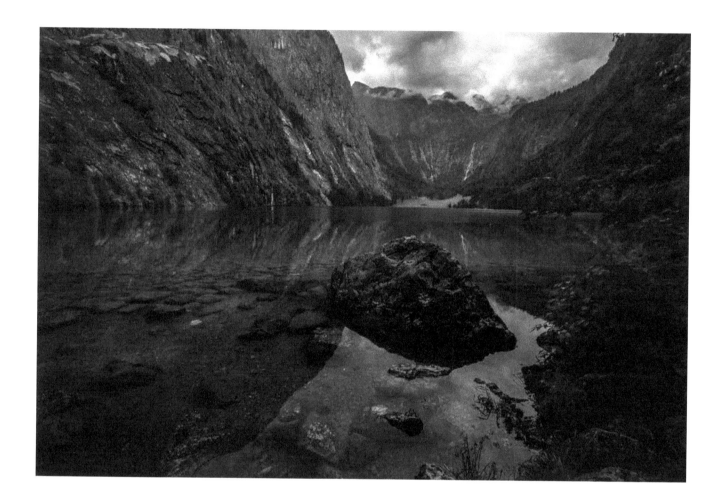

Originally upon coming to this scene, I had walked through an opening in the bushes. As I came into view of what was before me, I was simply stunned and just took the moment in of this beautiful location.

In this case, by using the wide-angle lens and keeping foreground in the image, it gives the viewer a sense of coming in through the bushes into the scene, as I did while there.

Also take note of the placement of the waterfall and horizon line. Notice they are not centered, but purposely placed in the thirds of the photograph. Here I am using the rule of thirds technique.

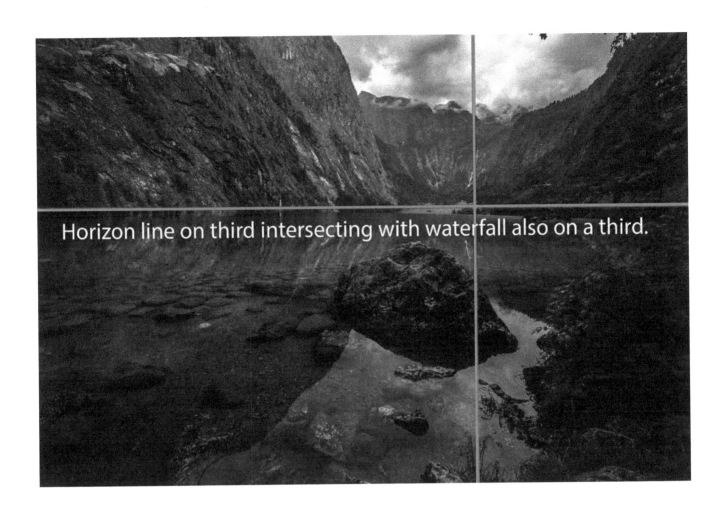

Horizon line on third intersecting with waterfall also on a third.

This photograph above was taken while on tour in Iceland. Look at the use of foreground. My feet were just out of the frame. If I were to "walk" into this scene, it would have simply been a step forward. This is what I am working to achieve for my viewer.

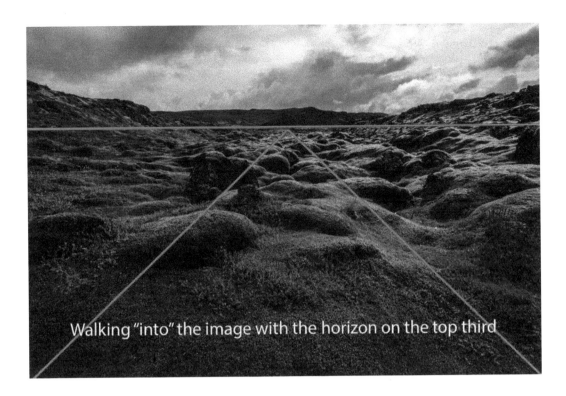

Walking "into" the image with the horizon on the top third

Leading Lines and Curves

Another aspect of wide-angle lens use I like is to use leading lines and curves. When I say, "leading lines," I'm referring to lines that lead the viewer to another point in the photograph. Leading lines can come in all sorts of ways and are not necessarily straight. You can use these lines in your foreground to once again lead the viewer on a visual journey into the image, as I've explained a bit in some of the photos I've shown already.

My technique for using lines with a wide-angle lens is to simply find my lines that lead to a subject and then point the camera down to right where if my feet were to move forward, the viewer would see them. In this way, it is giving that sense of "walking into the scene" visually following the leading line.

In this image below, by using a line, in this case the ocean shoreline, the line allows it to line up directly with the rock formation and visually direct the viewer to that formation.

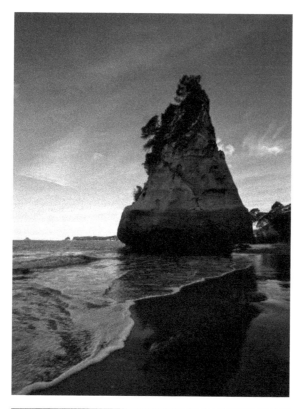

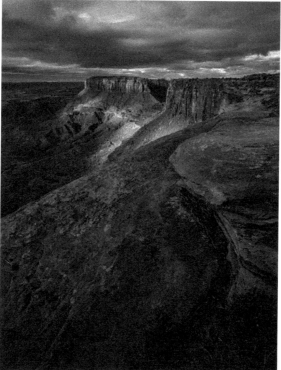

In this image above taken in Moab, UT, see how the curve is leading you visually into the image.

Low-angle Shots

By getting down low and close to your subject, you can create a very different perspective than most people are used to seeing the world. In doing so, you add drama to your image. You can turn the normal, or the expected, into the extraordinary.

Since you are shooting with a wide-angle, not only can you include your main subject up close, but you can also capture everything that is up high in the same image. This can be very powerful and striking.

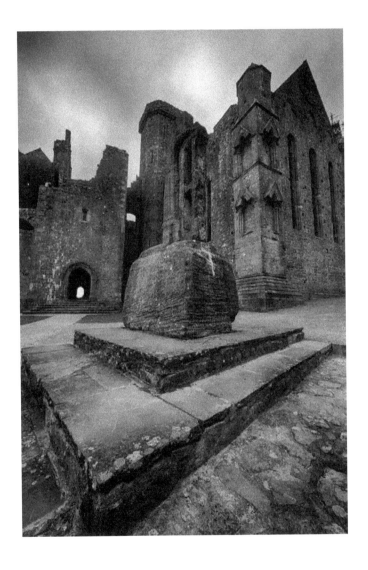

In the above image in Ireland, I was literally only a foot or so away from the beginning of the step. I had the camera on the ground to get this image. Because it is with a wide-angle, it allowed me to not only capture the scene and castle behind, but created a sense of power in the foreground due to the perspective distortion shift that happens with a wide-angle lens.

In this image above of a beautiful American classic car in Cuba, I once again used the wide-angle lens not to capture more, but simply to create a very different visual perspective. By getting low, using the outside of the lens to distort perspective, and by getting close, I was able to get this unique view.

Lens Flare and Sunburst

Wide-angle lenses tend to get more "flare" from the sun. This can be a distracting element in an image, OR you can use it to enhance the image and subject.

This is talked about in length in my second book. The crux of my teaching is that by using a wide-angle lens and getting your f-stop to a small opening (a large number, like 22), it helps to create a sunburst, which can add a compelling element to an image. Be careful NOT to look right at the sun!

This image below was taken with a 14–mm lens. I have found that with my 16–35mm lens, I cannot get near the starburst effect that I am able to get with this lens. It has to do with optics and the way light responds to those elements.

Your Own Shadow—Beware!

As you are getting more of the scene in the image, sometimes if you are not careful, you can include your own shadow. Be careful to avoid this. When the sun is at your back later in the day, it will cast long shadows that can come right into your scene.

The image below is quite obvious; however, many times when I have not been paying attention, my own shadow or that of others has crept into my image, uninvited.

However, as you can also see, you can work with shadows and have some fun, as in this image below. A wide-angle lens allowed me to be able to get this shot.

21—Telephoto Lens

This lens is the obvious choice for when you want to zoom in on a certain subject, like in sports or wildlife. However, what about the not so obvious in a scene, such as landscapes, details, shapes, and designs? Just as I mentioned earlier, by using a telephoto in landscapes, you can get an entirely different perspective than most people are used to seeing.

Isolate

By choosing a telephoto lens, you now will be looking for specific pieces within a scene that are interesting. It is much more than just zooming in on something. It is looking, seeing differently, and finding the gem in a scene that many people would never notice.

Work to find interesting lines, features, and details within a scene. By isolating those elements and then using a telephoto, you can often show a viewer something they would have never seen, thus creating impact for them visually.

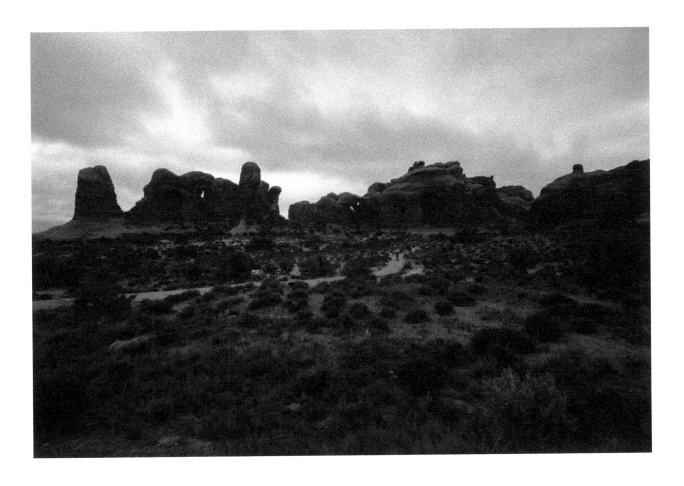

In this example above, although it is a nice landscape image, by trying something different and using a long telephoto lens, I was able to capture the image below from the exact same location.

If you look closely at the image below, you can see Toby from photorec.tv. He is just a little speck in black, and it shows you just how large this arch is!

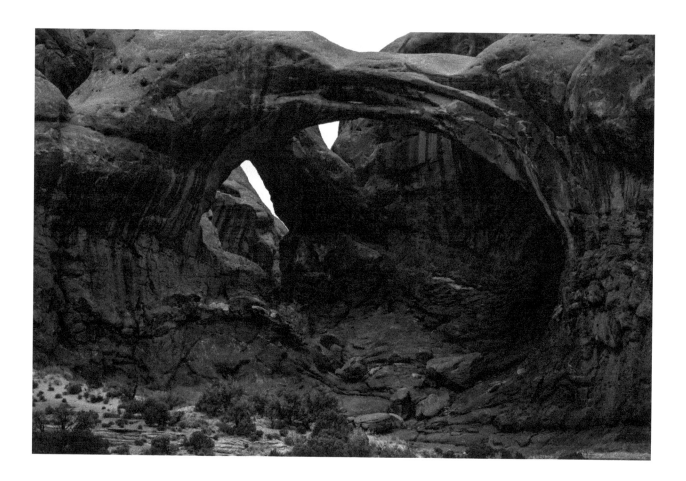

Compress Perspective

Telephoto lenses tend to compress the visual elements in a scene, meaning to make nearer and more distant elements appear closer together. This can produce another impacting result in your image. In this image, which was taken a good half a mile from me, I used my 600-mm lens to help compress the foreground and background. By doing so, the mountain range behind the red rocks, which is another 25 miles away, looks as if it is just behind the rocks, thus forming a beautiful background to complete my scene.

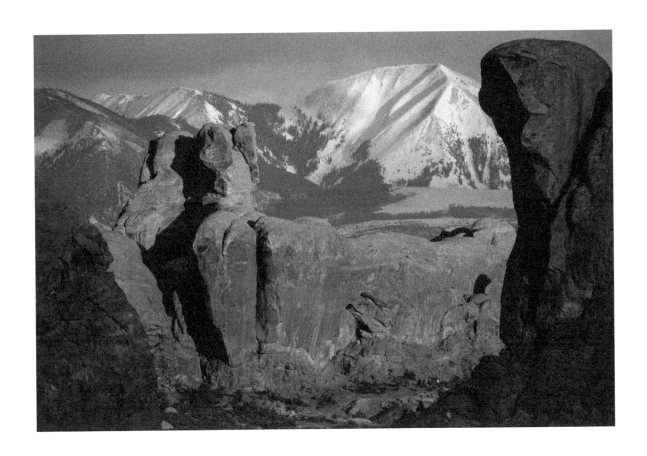

22—All-in-One Lens

Many people prefer the flexibility and versatility of what is known as an all-in-one lens. Let me be clear on this. No one lens can do everything! However, for those that prefer to travel a bit lighter, do not want to carry more than one lens around, and also love to have some of the best of both worlds in focal length, this can be an excellent choice.

These lenses come in a variety of focal lengths, but usually they are in the range of around 18–300mm or thereabouts, depending on the brand and cost you want to spend.

There are some downsides. First these lenses are not going to be the quality of the very high-priced, top-of-the-line lenses some may prefer. They also will not have a low number aperture and, therefore, cannot let as much light in. Yet, for the average amateur photographer, especially those just starting out, these can be a great way to go.

There are many brands and manufacturers that make these lenses including the camera manufacturers themselves. It is best to do some research on the brands and see what other have to say about what they purchased.

As I said, these lenses cannot handle everything, but for many people, including clients of ours, they have found this to be a great alternative to carrying too much gear, and they enjoy the versatility of a little wide all the way to a long telephoto in one lens.

23—Time with Your Subject

The rule here is just as it sounds. In order to photograph and make the most of a scene, you should spend time exploring it. Too often, I notice people shoot one or two images, and then move on without really taking time to explore what they were shooting.

My general rule is that if something was interesting enough to get our attention, it is worth exploring from different angles, perspectives, and compositional ideas. Do not be in a hurry to move on.

We call this "working the scene." Many times I have felt there was an excellent photograph to be had, and yet, I just couldn't seem to get what I had hoped for in the image. But after spending time, walking around my subject if possible, exploring angles and light, and playing with various lenses, I have been able to work through the process and get some great images. This, of course, is one more reason to go on a photography tour versus a regular tour.

24—Get to Know People and Culture

If you go to Europe and do not sit in a square of a local town and enjoy a cappuccino or a beer with the locals, you are missing the whole point of traveling! Yes, in my opinion, you are.

Part of the travel and photography experience is to broaden your horizons, meet others, share in culture, and make friends. I can say I have friends all over the world, and I am truly not exaggerating. With today's social media, I can literally keep in touch with friends in faraway lands, like Tanzania, or just a few states over in the Midwest.

In fact, there has even been times when I have been instant messaging various friends I have met during my travels that are on different continents, all in the same five minutes of messaging time. One friend is instant messaging me from Tanzania, while another one is from Europe. It is so cool to have conversations and keep in touch with people nowadays, all in an instant, anywhere in the world! How cool is that!

Below are a couple of images of artist Dimitri Kolioussis. Dimitri is one of the world's most famous and sought-after artists of Byzantine-era icons. He is also one of the most humble artists I know. After being introduced by another mutual friend of ours while on tour in Santorini, we have developed our own friendship. Ally and I can literally come in unannounced, (he is never online so we have to) and Dimitri will stop everything, have us sit down, grab us a drink, and spend hours talking life, art and whatever else comes up.

He has been in his same studio located in a white cave within the cliffs in Santorini for over 50 years now. His works have sold for hundreds of thousands of dollars, and some of his art hangs in churches all over the world. Yet, he will stop all he is doing, just to have conversation!

This is the type of relationships that should feed and enrich your travel experience and your photography. In fact, after talking with Demitri, you cannot help but step out with a desire to go and create and see the world differently!

New Polaroid Idea

As I have traveled the world, I am always looking for a way to connect with culture and people, even when not knowing the language. Many times I've found myself wishing that I had an old-school Polaroid on me to just snap a quick pic with a villager or child, and give it to them as a memento of our friendship. Well, NOW I can, and you can too!

There is a new Polaroid-style camera these days. It uses no ink, and each cartridge will give you 50 photographs. Why is this so cool?

Because it is awesome to take a photograph of a child or friend you just met, and give them a picture on the spot! Talk about creating a bond! You can even write your email on the back if you desire.

Here is one of our clients, Tracy, handing over a polaroid on the streets of Cuba. Many of these people may not even own a photograph of themselves or loved ones. When the images come out of the camera, the expressions on their faces are priceless.

Sure, you are not going to win any photography awards with it, but what a fantastic way to connect with those around the world and create an instantaneous memory. Let's face it, no matter how good your intentions may be to send a photograph to someone you meet, how often does it ever really happen?

With this camera, you will always be able to do something special, right there in the moment.

It is also great if you want to photograph a street performer, for example. Take a photograph with your nice camera, then take a photograph with your Polaroid, and drop it in the hat with a couple dollars. It will make their day!

Get yours here! http://amzn.to/1UwfqcN

We should ALWAYS be considerate of others and try to leave the world a better place than how we found it. This is a small personal way to do so, in my opinion.

I have said it before and I will say it again. *Your experiences should feed your photography.* By knowing the people, hanging out, and creating friendships, your travel and photography will take on much more meaning than just nice photos of your trip.

I'm going to be honest here and a bit "sappy." As I was just writing this above, it really hit me that all of my work and life as a photographer is not measured by how great my images are, how many I have sold, or what galleries they may hang in.

It is really measured by the experiences I have had, the cultures I have witnessed, the people I have shared photography with and shown how to "see," and, most importantly, the lifelong friendships around the world I have formed.

That is priceless to me and something I hope every one of you reading this book gets to experience in some way.

Here I am in Mozambique, Africa, in 2001 with my "friends" from the local village!

25—Tell a Story—Create a Book

The saying, "A picture is worth a thousand words," is very true. One image has the power to convey thousands of words and impact the world. However, let's be real for a moment, shall we?

Not every image you are going to take is going to change the world, tell the story of your travels, and be the perfect image. I want you to be okay with that!

For myself, I will shoot hundreds, if not thousands, of images on a trip. Out of all of those, usually only a handful ends up in my gallery as an art piece. I realize that not every image I take is going to be a masterpiece.

However, it doesn't mean that many of those images are not valuable! The other images may be memories or snapshots I do not want to forget or want to convey to others about my travels. There may be images that tie scenes or a moment together, and help provide an outline of a trip or of areas traveled.

Something I have found that I enjoy doing is creating books of my travels. There are a ton of easy-to-use companies these days that will create a coffee-table-style of book with images that you have chosen.

Blurb is one that I use and really enjoy because they have excellent hardcover books with premium papers. They also have very easy-to-use templates where you simply drag the images in and they are ready to go.

By knowing about this custom "travel photography book," I know when I travel that not all of these other images from a trip are going to go to waste. This allows me to shoot simply for the idea that the image will be part of the story.

Another example of this is a book I recently did for my sister. My sister loves lions. She has her whole life. As I have been fortunate enough to photograph both trained lions as well as those in the wild, I recently created a book for her of the many lions I have seen and photographed. For her, there is probably no better gift I have ever given her. Why? It was personal and special.

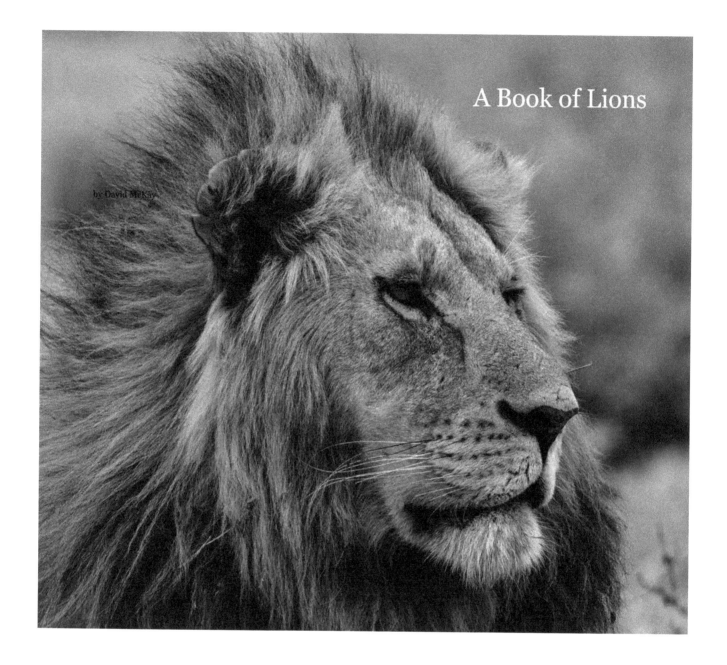

A Book of Lions

by David McKay

Not every one of those images in this book was a gallery, award-winning art piece, in my opinion. However, by utilizing images I had taken of various moments in my travels, the book itself became the art piece.

I currently have plans to take images from some of my favorite locations I have traveled to more than once, such as Iceland and Tanzania, and create coffee-table-style photography books from those travels. Why? Because it is a way I can share the images I have done with anyone who would like to see. That is good enough for me!

26—Winter Condition Photography Tips

In the event you go to a cold weather location on your photography tour and because I'm a big fan of cold weather photo journeys, as you'll soon read in the "Iceland" chapter, I'm including this special chapter to share my hard-learned cold condition photography tips. Also, I'm including my recommendations for winter weather clothing.

The first thing you need to consider when shooting outdoors in the winter (or at least, in snow conditions) is the temperature. Sure, you're all bundled up, but what about your camera? The batteries in your digital camera don't react well to the cold; it reduces their output. That's why your mom always kept new batteries in the fridge, right? Keep your camera warm by carrying it under your coat, as close to your body's warmth as possible. And carry extra sets of batteries in a warm place too.

Keep extra sets of batteries stashed in pants pockets or in the camera bag in a van. Rotate the batteries to give them a chance to warm up again. Otherwise, cold batteries act like dead batteries.

Though most digital cameras are specified by their manufacturer only for operation down to a temperature of 0 degrees C (32 degrees F), most will work perfectly well at much lower temperatures. They aren't rated for lower-temperature work because they aren't tested to fully meet all specifications at those temperatures and because there are some problems that can occur, as detailed below, at 0 degrees C, but most of those problems can be avoided. Electronics actually often work better at lower temperatures, so there's really no issue with the electronic circuitry.

Batteries

As I just explained, exposure to extremely low temperatures will drain the battery more quickly. It's impossible to measure just how much more quickly the battery will drain, but it could run out of power anywhere from two to five times more quickly. To decrease the effect of the cold on your battery, remove it from the camera and keep in a pocket close to your body. Only place the battery in the camera when you're ready to shoot. It's also a good idea to have an extra battery or two ready to go.

Cameras

Although the entire camera may work more slowly and intermittently in extreme cold, one of the biggest problems the camera may suffer is condensation. If there is any moisture inside the camera, it could freeze and cause damage, or it could fog over the lens, leaving the camera unusable. Warming the camera should fix the problem temporarily. You can try removing any moisture from the camera by sealing it in a plastic bag with a silica gel packet.

If you're using a DSLR (digital) camera, it's possible that the internal mirror could jam because of the cold, leaving the shutter unable to work. There really isn't any quick fix for this problem, other than raising the temperature of the DSLR camera.

Coming In from the Cold

A major problem with cold-weather shooting can occur not while you are outside, but when you come back into a heated area. Very cold air is very dry, but air in a heated room usually contains moisture. In fact, many homes use a humidifier during the winter months to keep the air moist because it's more comfortable for people. If you bring a very cold camera and lens into a room with warm, moist air, moisture will condense out of the air and onto the cold surfaces. The problem isn't so much the moisture you may see on the outside of the camera or lens, but the moisture that condenses on internal parts. Electronics and moisture don't mix well, and you really don't want condensation on the inner elements of lenses either.

The good news is that the moisture will eventually evaporate if the equipment is allowed to warm up to room temperature, but it can take a long time. You can *gently* warm the gear with a hair drier on a low setting to speed things up, but a much better procedure is not to let the moisture condense in the first place. If you do get condensation on a camera, remove the batteries and don't put them back in until you are sure the camera has dried out. Just because a camera is "off" doesn't mean that electronics are safe from damage. Many cameras are just in a "sleep" state when off, with power still applied to some components.

You can avoid problems if you seal your camera gear in an airtight plastic bag *before* you bring it inside. It will then be surrounded only by the very dry air from outdoors. You may get some condensation on the outside of the bag, but the camera/lens will slowly warm up in the dry air inside the bag and will stay dry. Self-sealing freezer bags work well for this, but any bag that you

can seal will be okay. Just be sure to put the camera/lens in the bag *before* you go indoors. Once you're indoors, it's too late!

LCD

You'll find that the LCD doesn't refresh as quickly as it should in cold weather, which can make using a point-and-shoot camera that has no viewfinder very difficult. A very lengthy exposure to extremely cold temperatures could permanently damage the LCD. Slowly raise the temperature of the LCD to fix the problem.

Hand Warmers

One way to keep your batteries warm is to wrap a small hand warmer around the section of the camera that contains the batteries (usually the handgrip for DSLRs). Hand warmers are small packets containing iron powder mixed in with a few additional chemicals, such as charcoal and salt. When the packet is opened and exposed to air, oxygen reacts with the iron (to form iron oxide, which is rust), and that reaction releases heat. The reaction is quite slow, and the heat can last anywhere from 6 to 24 hours depending on the size and design of the hand warmer.

Since these are intended to be used to warm hands and feet, they don't get really hot, so they are usually safe to use next to a camera. Carrying a few extras for your hands and feet might not be a bad idea too! If you don't want to wrap one around your camera and you keep your camera in a bag when you're not shooting, you can place a hand warmer in the bag next to the camera. It may not raise the temperature in the bag much, but even a few degrees can help.

Clothing for Winter Conditions

For spring, summer and fall, it is usually pretty simple and straightforward to understand what clothing you will need for a trip. However, when it comes to winter conditions, especially harsh winter conditions, I find many people are not quite sure of how to prepare if they are not used to being in this type of weather.

I should mention that winter cold in a location like Northern California is far different than winter cold in Alaska in the Arctic Circle. I have been in both and can tell you—you need to be prepared!

With the right clothing and actions, you can stay warm and cozy for the entirety of your vacation to any winter wonderland.

Underlayer

This layer is the most important! We wear polypro underlayers (breathable, soft fabric that isn't cheap, but it's so worth it). Even if you don't have fancy polypro, any type of long johns is better than nothing. They should fit you snugly without a lot of baggy area so that you can wear them under a variety of clothing. Avoid cotton, as it retains moisture, which will make you cold. Also, nylons are NOT the same as long johns or polypro base layers, and will make you cold!

Middle Layer

For basic activities, like sightseeing and city tours, we wear jeans most of the time. However, for longer outdoor activities, like dog sledding and snowmobiling, we wear a more flexible, non- cotton type of pants, like what you would buy in an outdoors store for hiking. Even the zip-off-into-shorts kind is acceptable (though you won't be using them as shorts in the winter). On the torso, another long-sleeved, non-cotton shirt layer is good, one slightly heavier than the underlayer.

Next Layer

Another layer on the top is preferable, like a sweater or light fleece.

Outer Layer

Snow pants or ski pants are great for outdoor adventures. Use pants that are made for snow, not just any waterproof outer layer. Snow pants don't let moisture soak through or snow stick to their outside, so no matter where you sit, lie, or fall while outside, you aren't going to get wet. They are also insulated. For the upper body, a parka or winter jacket with a hood is ideal. The hood provides added protection for your neck even though you will have a hat on. Jackets made for skiing or snowboarding are the best kind because they won't let snow stick and make you cold.

Feet

Multiple layers of non-cotton socks are the way to go. One layer, if it's the right kind, is fine, but more layers of thinner socks are better. We start with a thin, cold-weather sock and then a slightly thicker sock over the top. We like the kind that go up to our knees because there's less chance of snow sneaking between the boots and snow pants and actually touching your skin.

Boots are so important and should be paid close attention to. Sorel is a good brand, as is North Face. While a huge boot rated to well below zero is great for dog sledding, it can be a little cumbersome for going around a city. Boots that only come to the ankle are not sufficient in many types of snow conditions, even in snow-prone cities. They should be taller. Often the warmest types are described as a "pack boot."

Head

Real winter hats, that cover your ears, are a must. It is preferable that the hat has ear flaps (warmer), but beanies are fine too, especially if you have a hood on your jacket. Scarves are really nice, especially for wearing around a city with fewer layers. They really keep the cold from creeping in around your neck!

Hands

Mittens or gloves will work. HOWEVER, it is harder to shoot photos in mittens, yet they tend to be warmer.

> **TIP:** Some locations will have the availability to rent out winter gear. This can save you the expense of purchase and also the hassle of extra luggage to carry it all.

Part Four—BONUS

A Guide to Two of my Favorite Destinations

The world is a book, and those who do not travel read only a page.

—Saint Augustine

As I have the wonderful privilege of being able to travel and photograph many parts of the world, I am often asked the top locations I like to go. I am going to share two of my very favorite places in this beautiful world I have been to and photographed. I will also share with you some tips about each location as well as some of the gems you should venture to.

However, in answering the question of what is my favorite place to go to and photograph, **I honestly have to say that it is the locations I have yet to journey to!** There is so much this world of ours has to offer. It seems that there will never be enough time to see all of it. So for me, I am constantly looking at the next great location(s) I will visit. As I write this, I am currently planning a trip to Croatia and Vietnam. I literally can't wait, yet, before then, I have other trips we are doing.

So the truth be told is that the locations I have yet to see and photograph, the people I have yet to meet and have a drink or break bread with, the adventures and wrong turns I have yet to take, and all the journey's that await—those are my favorite places in the world.

27—Iceland—Land of Fire and Ice

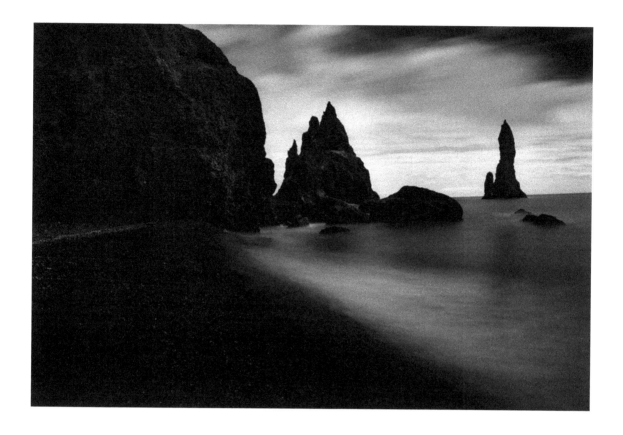

If you are looking for an ultimate landscape photography destination, Iceland should be considered for the top of your list. Forged by thousands of years of volcanic and glacier activity, Iceland offers the landscape photographer endless opportunities. Full of waterfalls and scenes that are straight out of a movie (many movies are filmed there), Iceland will afford you photographic bliss at every turn!

Although there are many times of the year worth visiting, going during the summer months allows you to journey around the entire country, including inland roads not accessible during the winter. August is a great time to visit as many of the tourists have left and weather tends to be mild and comfortable most days, but still, it is Iceland, so preparation for any conditions is a must!

A flight into Reykjavik will get you started. Route 1 circles the entire island and will actually give you ample opportunity to visit many of the iconic sites of Iceland. It is best to have a game plan going in if you are limited on time. Twelve to fourteen days is a good amount of time to see much of the country's beauty, and I would highly recommend booking your hotels at least a year in advance. Iceland has become popular, and it seems it is now "the" place to go for many people!

Photographing the Landscape

Iceland is filled with an incredible diversity for landscape photography opportunities. In my opinion, it is one of the best, if not the best location in the entire world for landscape images to be made.

Iceland has everything from volcanic activity to farmland, to icebergs and glaciers and waterfalls. Even the puffins are plentiful in Iceland!

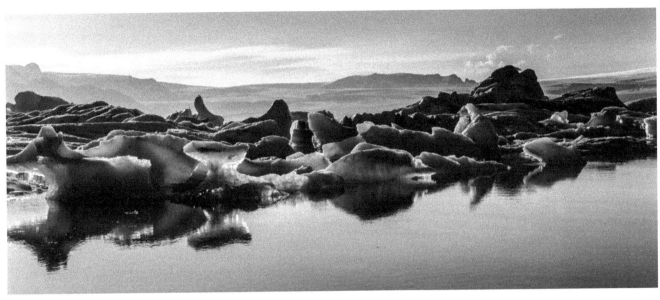

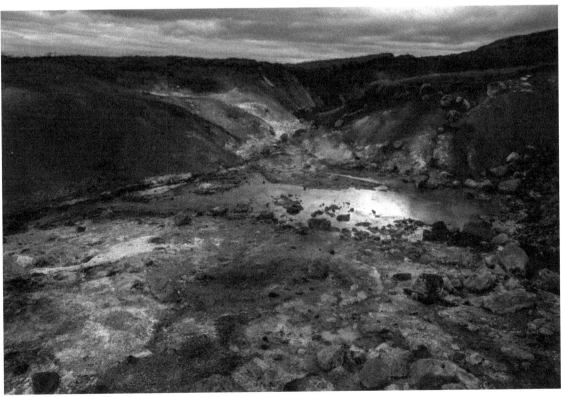

As you can see in the above two images, Iceland is full of extremes. In the first image you have glacier ice filling a lagoon; while in the second, there are volcanic mud pots with sulfur and boiling water.

Personally, I do not tend to shoot with filters much. However, Iceland is a location where you will want to have a few on hand, for sure. A polarizing filter to help reduce glare from ice and water and ND (neutral-density) filters to allow long exposures of waterfalls during the daylight are highly recommended and well worth the investment for photographing in Iceland. I recommend a #8 ND filter. (Please see my first book for a complete section on filter use.)

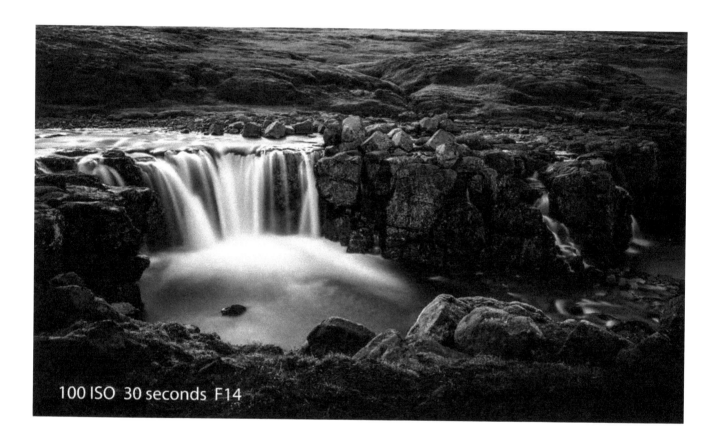

100 ISO 30 seconds F14

A solid tripod that will not move in the wind will serve you well. You will not be able to run to a camera store once out away from Reykjavik, so be prepared with backup systems in place. Extra batteries, memory, and a backup camera body are a must! I am always amazed at how many people do not have a backup camera on a trip like this. If yours goes down, and believe me, I see this happen a lot, you will be devastated at not being able to do what you planned.

Be sure to have microfiber towels you can quickly wipe down your camera with as well. A rain cover is a perfect way to protect your camera if you are dealing with inclement weather and/or spray from the waterfalls.

Waterfalls, Waterfalls, Waterfalls!

Iceland is full of waterfalls, so much so that you will find yourself passing many and thinking, "Oh . . . just another waterfall"! I will share with you a few my favorites that I have been fortunate enough to photograph. This is by no means an exhaustive list of the MANY waterfalls available to photograph, but these are some of the most popular as well as most unique and beautiful.

Barnafoss

Barnafoss waterfall is not your typical single big fall of water but rather a series of small waterfalls all coming down the side of a river gorge into crystal-blue, beautiful water. It reminds me of chocolate cake with oozing sauce running down the side. It is one of the most unique waterfalls in Iceland and without a doubt, one of my favorites.

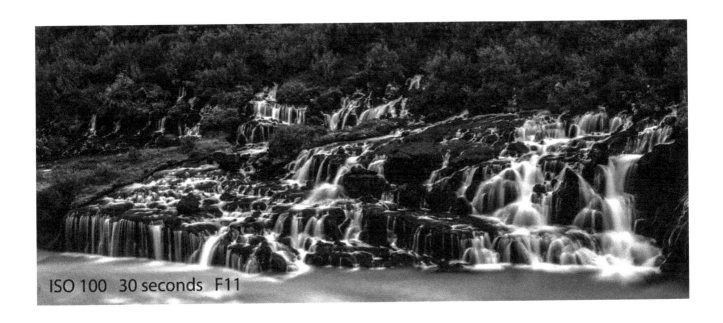

ISO 100 30 seconds F11

As you can see, I used a 30-second exposure to create this image. This was done by using an ND filter to cut down light, as it was bright and during the day when I was taking the photo. In most of the following images, the exposures were very much the same, using the ND filter in order to get the effect of water flow I desired.

Gullfoss

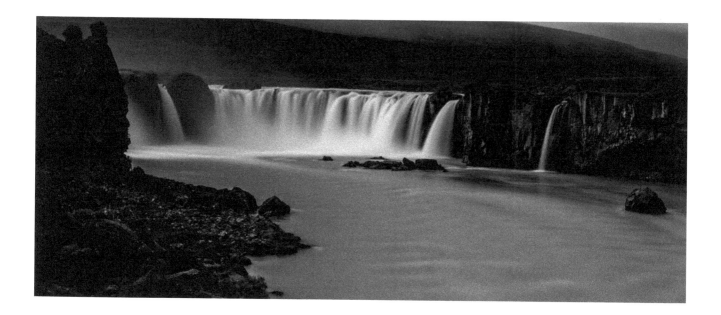

Gullfoss is a very popular destination for tourists and photographers alike. As with any location, the earlier you get there or later you stay into the evening, you'll encounter the best light, but also it will help you with the thousands of tourists that will come in busloads to this place.

Gullfoss is not far from Reykjavik, so many people visit on daytrips, making it very touristy. However, no trip to Iceland should miss this site. Be sure to arrive no later than 7 am, and you will be alone for a while. By 9 am, the crowds will begin to arrive, and by 10 am, the place will seem totally overrun.

Skogafoss

Another iconic waterfall, heavily visited by tourists and photographers alike, Skogafoss is another unique, huge waterfall. Once again, it is a must to arrive at Skogoafoss early or to stay late; otherwise, many tourists will end up in your image, and you will spend forever Photo-shopping them out if you don't!

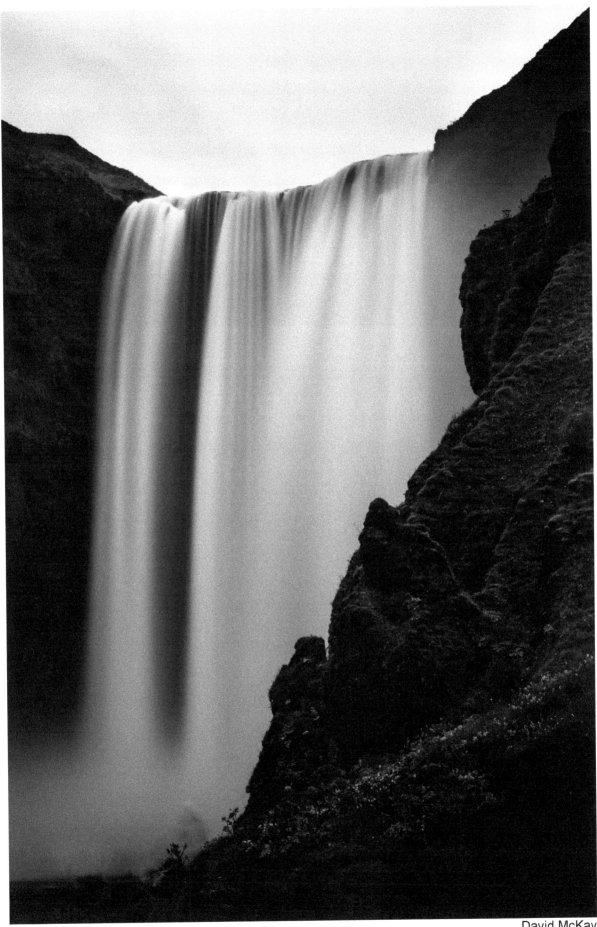

As with many locations, Skogafoss offers a number of places to shoot from. Down along the riverbed leading up to the falls themselves will provide a nice composition to photos. Climbing up the steps along the side to gain a view is interesting, yet it doesn't give you the best vantage. However, about halfway up, there is a small path that leads you out to a small rock cropping. This is a great place to shoot from but also can be very dangerous. Be very cautious as you make your way out to the point. It is slippery, and one wrong step can be fatal. It is not for the faint of heart or for those afraid of heights. Yet, it is an awesome vantage point.

Another option sometimes missed by landscape photographers is to actually use a person in your image to give a sense of scale. Do not be afraid to actually have people in your image to allow the viewer to sense how massive Skogafoss, or any other waterfall, is.

Dettifoss

An extraordinary waterfall two hours out of the way of most major roads is Dettifoss. Here, you will find very few tourists and Europe's most massive amount of water per second flowing over the edge. Powerful is an understatement.

There are two roads that come into Dettifoss, so ahead of time you will need to choose which direction you want to come in from because you cannot cross once there. Coming in from either direction allows for incredible scenery and massive cliffs that have been carved out through time.

As you approach the lookout point, you will get a sense of how incredible Dettifoss is, and you will hear its thunderous roar and power. After shooting from the lookout point, make your way along the rocky paths to the edge. I have seen some people literally lean over to get an image here, and one small mistake would mean certain death. I do not care how incredible an image can be because, for me, this amount of risk is not worth it. Stay back and shoot, and you will still get spectacular images.

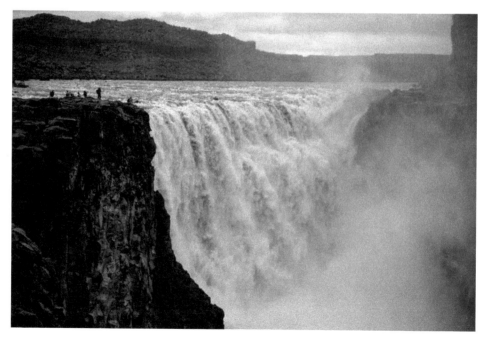

With many waterfall images, I tend to prefer that silky-smooth long-exposure feeling in the photograph. However, Dettifoss is a waterfall I particularly recommend shooting with extreme shutter speeds. What I mean by this is to vary it up. Feel free to take some long exposure images, but also, boost your shutter up to its highest value of 1/4000th of a second, or 1/8,000th of a second if your camera allows it, and capture the power and texture of this incredible waterfall.

Dettifoss is also another location where it will serve you well to add a sense of scale to the image by allowing a person or people in some images. In the image above, I photographed at 1/4000th of a second and kept people in the image for scale.

Seljalandsfoss

Seljalandsfoss offers the very unique opportunity to walk up and in, behind it, which is one of the reasons it is one of my favorites. Follow the path from the parking lot up to the right and then walk directly behind the falls. If you go later in the evening, you will hopefully be able to catch a beautiful sunset glow as you shoot though the falls and also have very few tourists around.

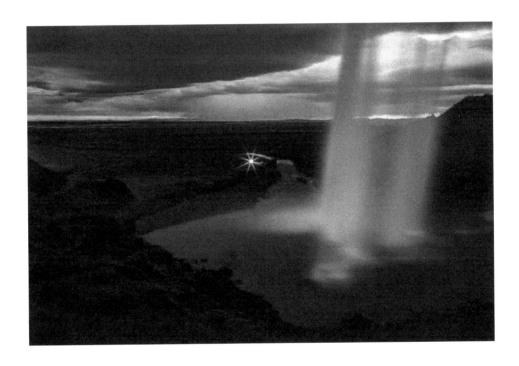

A wide-angle lens is an excellent choice at Seljalandsfoss because you can capture not only the water flow with a wide-angle, but the cave makes a great "frame" of your image. After shooting from behind the falls, be sure to explore the many angles available to shoot from. If you keep walking behind, then just to the right of the falls, you can take the steps up to another area where another waterfall drops into a pool below.

The image above was at sunset, so no ND filter was needed for the long exposure as it was already dark enough.

800-Year-Old Ice

One of the many awesome places to go in Iceland beyond photographing so many waterfalls is to areas where glaciers are breaking off and flowing as big, beautiful icebergs into the sea. The most famous location is known as Jokursallon, or simply Glacier Lagoon.

During the day, once again, you will find many tourists, but you'll have the opportunity to take a boat out to inspect some of the pieces of ice. It is a unique experience worth doing.

Be sure to plan to spend HOURS at this location unless you have a hotel nearby. Many people take a one-day tour here. It is a long day, and you will feel rushed at the glacier.

My recommendation is to go shoot in the morning, then take one of the first boats out on the lagoon prior to noon.

During the day, if the sun is out, the color from the ice glistens from the sun, so a polarizing filter will help with glare. I love shooting the ice at Jokursallon at midday on sunny days. Yes, I just said midday! Why? It is truly beautiful to see the ice glisten on a sunny day.

I personally find that shooting from the shore is as good of vantage point as any, and the boat excursion, while worthwhile for the experience, does not give any better views to shoot from. This image below was shot right from the shoreline just 50 yards from the parking area.

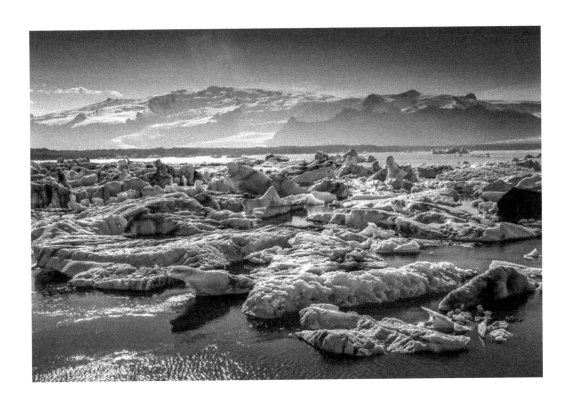

Shooting at 11 pm is not uncommon because it stays light so long during the summer months. For this reason, you can plan to come back late in the evening for beautiful light and spectacular moments with the ice.

As you come to the lagoon area, park across the highway away from the lagoon to access the beach. Here you will find spectacular formations of 800-year-old ice that have come down from the glacier, broken away, and made the journey through the lagoon and down to the ocean. These ice formations have washed back on shore against the black sand. You can spend hours mesmerized by this incredible place.

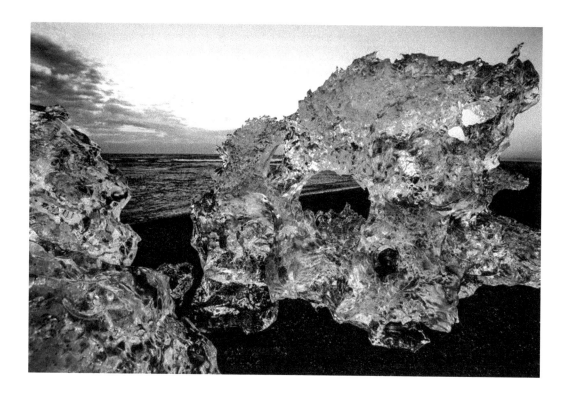

Down the road from Jokursallon, there is another glacier lagoon that is not nearly as well known and that very few people visit. This is the place to go to avoid the crowding of tourists in all your images of the ice. Simply follow Route 1 down just a little ways and turn right up the dirt path. Here you will find icebergs all to yourself most days!

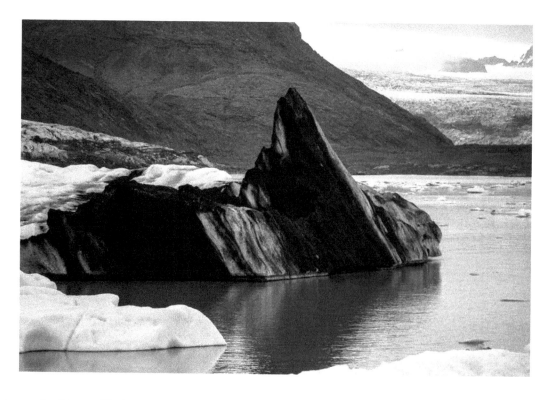

Heimey Island

To finish off your tour, a visit by ferry to the lesser-known Vestmannaeyjar (in English, the Westman Islands) is in order. In 1973, a volcanic eruption on the island of Heimey covered much of the town and created another one-third of the original landmass that you see today. The eruption also created a natural port that shields the island from rough seas, and this natural port sometimes has orcas as guests in it.

There is so much to shoot here that you must plan at least two days to photograph and explore. If you like to hike, venture up the hillsides for fantastic views of the island from above. A trip to the far side of the island will allow you to shoot beautiful cliff-side areas and the many puffins that inhabit it! Heimey Island in the Westmans is the perfect end to your Icelandic adventure!

28—Tanzania—Call of the Wild

This chapter is dedicated to my friend and guide Phanuel. Thank you for all you did in this life to show us the beauty of your amazing country. You will be missed my friend.

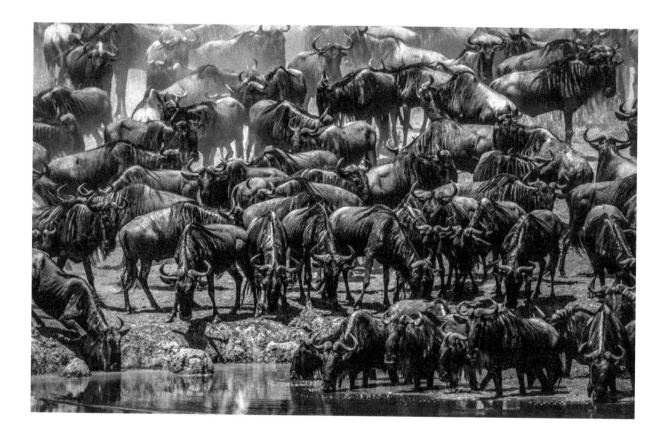

For many people, both photographers and non-photographers alike, a wildlife safari to Africa is not only a bucket-list item but one that is at the very top of the list. Recently my wife and I, through our photographic tour company, had the privilege of spending quite a bit of time in Tanzania leading photography tours. A Tanzanian wildlife safari is truly a photographer's dream!

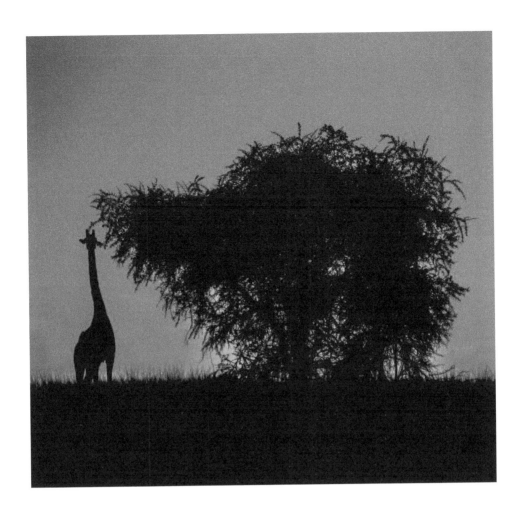

It is the *"call of the wild"* that will lead you to not only go on a wildlife safari in Tanzania but to return more than once because you will be transformed by the beauty of the landscape and the majesty of the animals there. Without a doubt, a Tanzanian wildlife photographic safari is one of the most fulfilling and exciting adventures you can do in your life.

I will take you through, point by point, some of the experiences you can expect as well as answer some of the questions and concerns most people tend to have about preparing and adventuring in Tanzania.

Safety

Like so many African countries, Tanzania is beautiful. Unlike many other African countries, the Tanzanian government has done an excellent job of creating a stable government and a safe country, and has worked hard to protect not only their wildlife through game preserves and protection programs, but also the many people that come to see such beautiful animals in their natural, wild habitats. You will find that Tanzania is a very safe place to enjoy a wildlife safari, but as with all countries, you should be aware of some facts.

The first important step is to ONLY work with top tour guides and highly rated professionals. There are over 400 wildlife safari companies in Tanzania. From experience, I can tell you that you truly get what you pay for. **Do not chance the trip of a lifetime on price!** With the right tour guides, you will be in safe hands from the moment you land until you depart. Your tour company should absolutely be available to pick you up at the airport when you land in Arusha and bring you back to the airport on departure.

Although Tanzania is a safe country, it is still a developing country whose people are severely impoverished. In Arusha you will see poverty and notice a huge difference from what it is like living in the highly developed USA. Arusha is the bustling starting point for most Tanzanian safaris. Use a company that will take you directly to your hotel from the airport. There are wonderful hotels, and you will find that tour companies do their best to shield tourists from the harsh realities of many of the people's lives in Africa. It is not safe to go out and wander the streets of Arusha on your own, especially with expensive gear in hand or at night. Once you leave Arusha for the wild, you will visit locations that will take your breath away.

The question that seems to be on everyone's mind these days about Africa is Ebola. I cannot tell you how many people have asked me about their concerns for Ebola. You have to understand that Africa is NOT a country but a continent. It is huge. In Tanzania, you are actually farther away from the Ebola situation than if you are in New York. Unfortunately Tanzania, as well as other countries, has suffered huge economic loss because of unwarranted fear and misinformation about the Ebola virus. Do NOT let that discourage you or scare you from going to Tanzania. It simply is not an issue.

With proper planning and the right tour company, you will find that a Tanzanian wildlife safari is very safe. Again, it is my belief that a Tanzanian wildlife safari is one of the most incredible experiences you can do as a photographer or just to enjoy as a tourist.

The Right Tour Company

As mentioned, there are over 400 and counting tour companies in Tanzania! Some are good, and many are bad. So, how do you choose? Our company works directly with one of the best, Thomson Safaris. We feel they are one of the very best for many reasons, but it does come with a price.

If you are signing up for a photographic tour, understand that all photographic tours, such as ours, still contract directly with a licensed tour company in Tanzania. It is required by law. It is important to know which Tanzanian tour company your photography guide uses and why. In our case, you can go through us, pay the same price as you would through Thomson directly, but also get our photographic guidance and education each step of the way with a very low client-to-instructor ratio.

There are other very good companies that do this as well. When choosing a tour company, do not choose solely based on price. If it's too good to be true, there is a reason. Potential clients have noted to me that they could go on a "similar" safari for half of what we charge. There is a reason for that, and you do not want to chance it! If you do, you may be sorry on your trip of a lifetime.

Here are a few things to keep in mind. Many tour operators stay in hotels outside the parks, so you have to drive each day into the park, sometimes an hour or two just to get to the entrance. This does not include how long it may take you to find good wildlife once in the park.

The Serengeti, as an example, is huge. The entrance to the park can be hours away from the best wildlife and what is known as the "Great Migration." The hotels may be nice, but who wants to spend their time driving hours each day and missing great images? A photo safari should be based on getting the best images and wildlife viewing possible. In the "Accommodations" section below, you'll learn how my tour handles the where-to-stay situation.

Many tour operators operate on limited miles. This means that the drivers are only allowed to drive so many miles each day. If you are spending your time just getting into the parks using miles already, imagine then how limited your actual "game drive" experience may be.

Imagine going on a wildlife safari only to learn that you will be packed into a vehicle with 8 to 9 other people and not be able to see the wildlife let alone photograph it? Many tour companies cut cost by doing just this. They pack groups together into every seat (sometimes even the middle), and their vehicles do not have open-air roofs for viewing. How miserable this would be! Make sure to choose a tour company that uses specially equipped Land Rovers for viewing.

If photography is your plan, MAKE SURE to go with someone that only allows 3 to 4 people per vehicle in the right type of Land Rover with roofs that open up, so you can stand and shoot. We situate our clients with four people per vehicle in a nine-seat Land Rover. And it is three clients and one instructor per vehicle. This allows not only for amazing photographic opportunities, but instruction as well during the safari, not afterwards, back at camp.

Be sure to choose a tour operator who works with the locals! Many operators hire outsiders as guides. I believe in supporting the local culture and people. Using operators with local Tanzanian guides, each with years of experience, is a must.

It is so important that your tour operator puts a good "team" of guides together. Some guides are great spotters, others are great cultural historians, and some are local tribes-people. It is important to have a team of the best so that your experience is well-rounded.

I also believe in working with companies that give back to the local people. The company we work with, Thomson Safaris, has been responsible for building schools, supplying clean water, hiring local people, and making sure communities flourish. This is very important.

Accommodations

Imagine waking up early each morning in your specially prepared Nyumba camp. Your "tent" is the size of a hotel room with all the comforts of home. The "call of the wild" beckons.

You awake each morning to a meal prepared by an amazing chef before the sun comes up. Your gear is ready, the anticipation of the day surrounds you, and then you hear off in the distance, elephants or the roar of a lion.

Your anticipation grows because you know great photographic images will soon be upon you. As the sun comes up over the horizon, you are blessed to see the most surreal sunrise of your life. At that moment, you see a male lion off in the distance, or maybe a female on the hunt, and your heart pounds—YOU are on a safari.

In another scenario, you wake up in a hotel, leave after a late breakfast, drive a couple hours packed in a vehicle with people you do not know, and hope for the best . . .

I think you understand now why price comes into play.

I HIGHLY recommend staying in Nyumba camps. These are camps set out in the wild usually for two to three months at the time when the Great Migration is taking place. This allows you to be close to the action and able to reach top wildlife-viewing areas within minutes.

Each camp has all the comforts of home. In fact, usually you have a dining area, a bar and relaxation area, your own personal tent with shower, bed with pillow-top mattress, fine linens, toilet, and sink. Each day gourmet meals are prepared by a chef while you can sit, relax, and just take it all in. Sound like heaven? Yes, it pretty much is.

Make sure to also go with someone that is able to arrange for you a "tech tent." This is a special tent set up with charging stations for your camera batteries and computers. A MUST-have on a photographic safari!

Camera Gear

This list is to serve as a "guide" for a safari. Each trip is unique; therefore, considerations must be made according to your own safari, the operator, and the season when you are going. There are usually weight restrictions in place, especially if you have to fly into the bush from Arusha. Be sure to check with your guide on this and work with someone that is able to arrange added-weight allowances!

This type of trip is unlike other situations in which you can just run to the local camera store should something go down. We see cameras and gear fail on almost every trip we lead. Whether it's in Africa or at home in the US, gear DOES fail. Be prepared; otherwise, all of your planning and investment can be ruined!

Bring two camera bodies. If you do not own a second one, don't hesitate to rent an extra body. The important thing: do not go without a second one.

Bring extra memory cards. You are in Tanzania. There are thousands upon thousands of images to be made. Be sure to have enough memory cards to complete the task. I personally use 32- and 64-gig cards, as I do not like to have all my images on one card in case of card failure.

Bring an external hard drive. Be sure to download all of your images each day, so they are in at least two locations. Cards do fail, and we have seen it occur many times.

Bring at least 3 batteries. You may or may not be able to charge when out on safari, depending on your vehicle and whether it is equipped to do this.

Bring a medium overall lens, focal length lens, AND a long lens. I tend to have two camera bodies on me at all times. One has a 24–105mm lens for these times when I find myself extremely close to wildlife. The other is a 150–600mm lens, which covers a great amount of length and focal range.

Lens Choices

I can hear it now, some of you photographers are already wondering what lens I must be using and you are ready to send me an email about how, as a professional, I really must use the biggest and best. So let's discuss that.

As I've stated several times previously, gear can be a very personal choice. I think that sometimes we put too much importance on gear versus talent. I personally believe a talented photographer with little gear can do more than a non-talented photographer with the best gear available. With that said, of course, putting a talented photographer with the best gear is ideal. But, let's face it, not everyone can afford an $11,000 lens! I want to make sure that you, the reader, understand that you can go on a trip like this and obtain great results without the most expensive gear. Do not let gear be a deterrent to a trip of a lifetime!

For my long lens, I use the new Tamron 150–600mm. Believe me, I purchased this lens and didn't really expect to see great results. However, for the price and the reviews I'd read, I thought it was worth a shot. To say this lens went beyond my expectations is an understatement. I truly did not expect the quality results I have been able to attain. Is this lens the best lens on the market? No. Is it an extremely fast lens? No. Is it weather sealed? No.

Okay then, why do I love this lens? I love this lens for its affordability, versatile focal range, weight, and quality. Yes, I said it—quality. Please understand, this is not an $11,000 f/2.8 lens, and I know

that as well as anyone, but for what it offers, I truly cannot complain. Most days I would rarely shoot at f/2.8 because the light is sufficient AND I find on animals f/2.8 can be too shallow for the depth of field that I want to attain. I do not want to see a nose sharp and the back of the head soft. So usually I am shooting at f/5.6 to f/8 anyway.

When I compared this lens to the Sigma 50–500mm and the new Canon 100–400mm, I found that the Tamron was great for its $1,000 price. The Canon, on the other hand, is an excellent choice. My wife uses this lens. I tend to like the range of the Tamron more, so I use the Tamron and am very happy with the results.

All of the images you see here are from this lens. I have no complaints really for what it offers for the price. Remember, if you are dealing with weight restrictions (you will be), the biggest and best weighs in at around 35 lbs. There can be huge extra-weight fees, so make special arrangements so that you can bring the gear you want to bring.

If you do not own the gear you need, no problem—you can always rent it! There are many companies today that rent out photography gear. Just be sure to understand their insurance policies, in case of theft or breakage. Renting is a great way to use some of the best photographic gear in an affordable way.

The Wildlife

Tanzania has many national game parks with some of the best wildlife viewing in the world. The most famous of these is the Serengeti. All anyone has to do is turn on National Geographic or Discovery to find something on most days from this area. This is because the wildlife in Tanzania is off-the-charts amazing.

On our most recent three tours in Tanzania, each tour truly had something special happen. No tour was better than the other. Each was unique and offered mind-blowing photographic and wildlife-viewing opportunities. This says a lot to what the area has to offer. An important part of being able to have these opportunities was the fact that we were staying right in the parks in our special Nyumba camps. Again, this style of accommodations allows us to be able to get up before sunrise and get out to the wildlife within minutes. It also allows us to be able to stay out and shoot as long as possible. There is no better way to do it. Tanzania truly will give you the opportunity to view and photograph the most incredible wildlife in the world.

You may have heard of the "Big 5." Everyone usually wants to see and photograph these five animals: the rhino, elephant, Cape buffalo, lion, and leopard. You will hear and be asked about the Big 5 many times. True, these are all a thrill to view and photograph, but there are many other species that are just as amazing, and that goes for birds as well. Of the Big 5, the rhino is the most coveted because of their low numbers due to human poaching. Elephants are also a target of poachers. Thankfully, the numbers are coming up, and rhinos are being saved. The work must continue for that to happen.

Tanzania has taken huge steps in protecting these beautiful creatures. This image below was photographed in Ngorongoro Crater of one of the few elephants that have tusks this long. In spending over a month in Tanzania, I did not see any elephants with these sized tusks until our last day!

He was estimated to be about 45 to 50 years old by our guides and fortunate to have survived the main years of poaching.

The Big 5 were given this name back in the days of hunting. This was because these animals have been considered the most difficult to hunt, and they can also be the most dangerous. You would be surprised how dangerous an "old bull" Cape buffalo can be!

All of these animals are located in the Tanzanian game parks. Most parks contain them all, but the populations can and do vary. Tarangire, as an example, is renowned for its huge population of elephant herds. Ngorongoro Crater, which formed when a large volcano exploded and collapsed in and on itself, is 2 thousand feet deep, and the floor covers 100 square miles.

The Ngorongoro Conservation Area has the largest population of animals condensed into one area anywhere in the world, consisting of over 25 thousand large animals all within the crater. This is also the place where you will have the most chance of photographing a black rhino. Of course, the great Serengeti plains contain all the wildlife species, and the Great Migration occurs there. The Serengeti is not to be missed on a Tanzanian safari.

The Great Migration

The Great Migration is truly a sight to behold and photograph, with over 2 million wildebeests and zebras as well as other animals continually migrating all year in a large circle around the Serengeti. This is another reason to stay in a Nyumba camp because these camps are set up according to the migration.

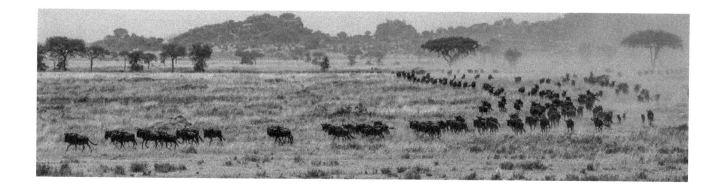

To see these herds, as far as the eye can see, for miles and miles, surrounding your safari vehicle is an experience unlike anything you can ever imagine. It is a must-go-for on a Tanzanian safari. You can see the migration year-round as long when you stay in a Nyumba camp. In fact, as you can see in the next image, you can literally find yourself IN the great migration at times!

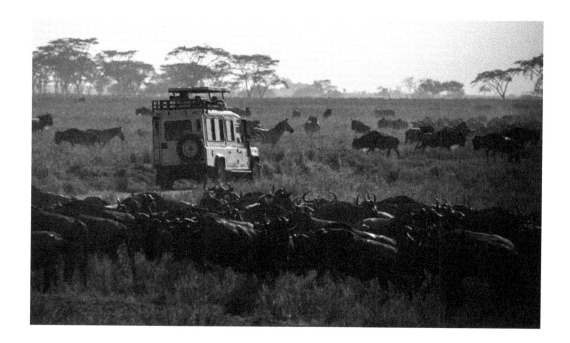

February is one of the most popular months because it is the time when the births occur, and, of course, predators abound with opportunities. March is a great time to go because the crowds have gone, and you still are able to see a ton of action, as baby calves follow their mothers around. Yes, they are cute. They also tend to be in danger from the lions looking to feed their young. It is the cycle of nature, and although it may sound disturbing, when you witness it, you realize that this is life and this cycle MUST take place to preserve the animal population.

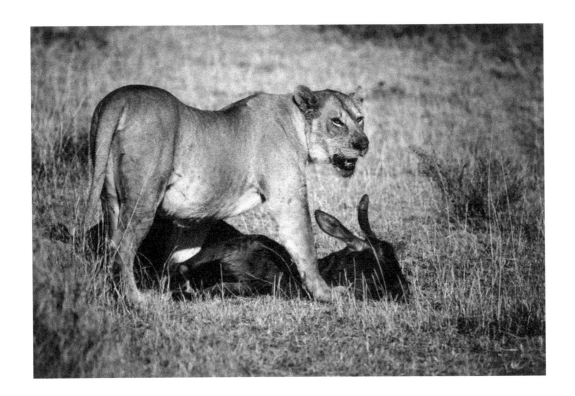

In February, there can be as many as 50 to 70 vehicles watching a "kill" whereas March, at most, there are 10 to 15 and usually even less. For that reason, I prefer March over February.

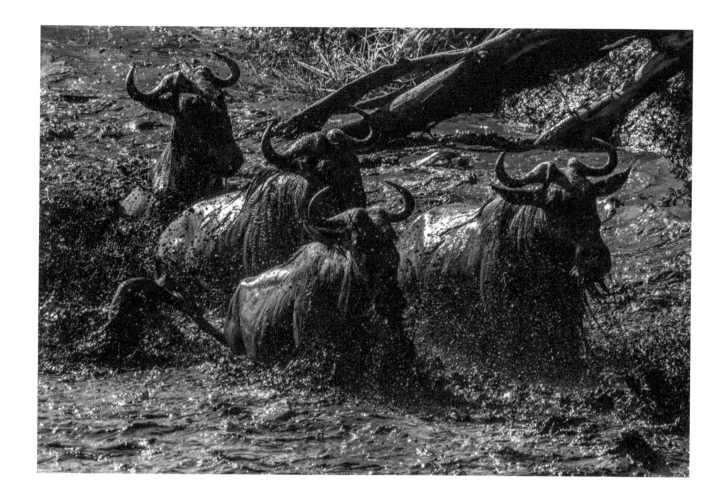

From August to November each year, the migration crosses the Maasai Mara National Reserve and Mara River into Kenya and back. This is where the crocs sit and wait for opportunities to strike. Your heart will pound in anticipation! Be sure to have your camera ready because when it happens, it happens fast.

The Culture

Another great photographic and life-changing experience is a visit with the Maasai people. Every Tanzanian safari should not only be about the wildlife but also about the beautiful culture of the local communities. The most popular are the Maasai.

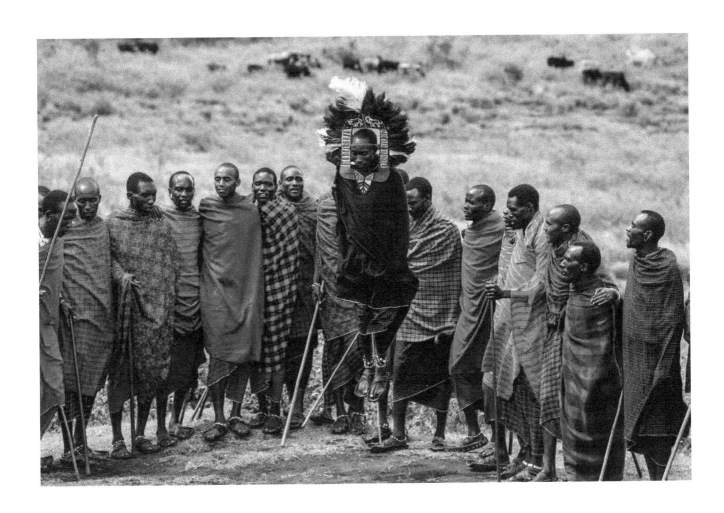

These are the people that you may have seen images of wearing red dress and herding their cows. The Maasai are living in a very interesting time. They struggle to maintain their culture and ancients ways, yet at the same time, they live in a modern world.

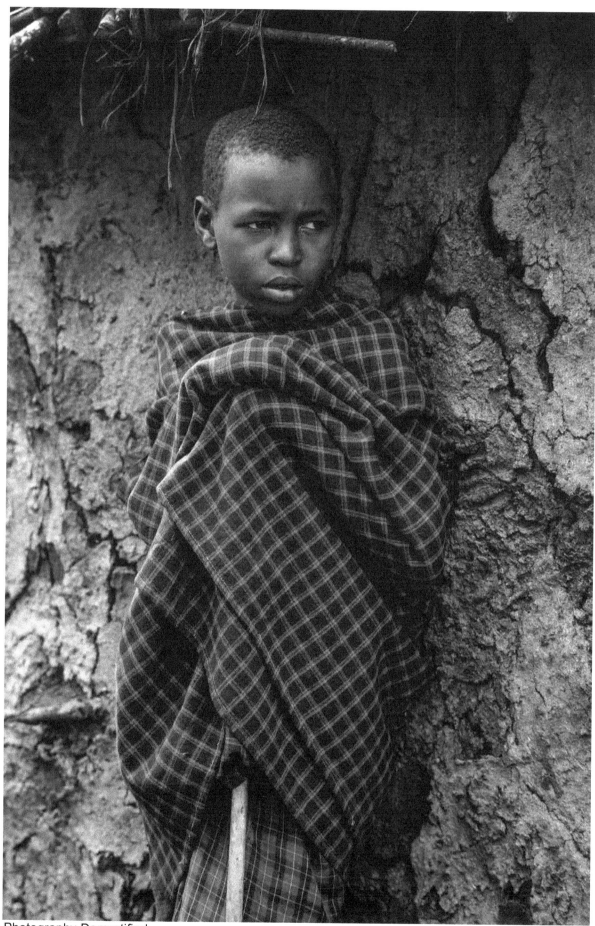

A visit to a local Maasai village for many of our clients has been a highlight of their trip. As you are shown around the village, you are taken into their huts that are made out of cow dung and mud. You are freely able to ask questions and take photographs. Of course, you may also be asked to participate in a jumping contest to prove your manhood!

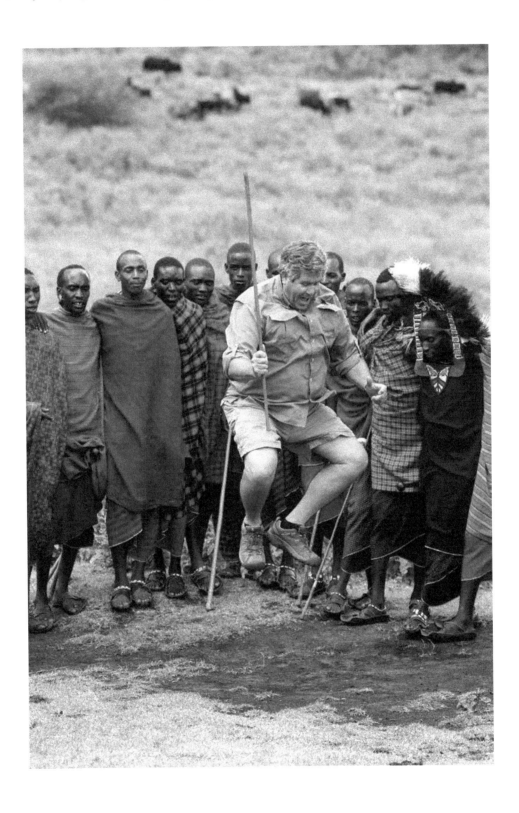

Later, you are then led to shop for goods they have made. The Maasai have learned the art of selling to tourists. Some people do not like this. I, on the other hand, applaud them for learning to thrive in this changing world and for creating work to provide for their families. I always ask people, "When is the last time you had to walk five miles for water or wood for your fire?"

I have no issues at all with the Maasai selling to tourists. They do love to barter, and it can be a challenge for some and feel pushy to others, but I applaud them for their keenness in what they do.

While at a village, be sure to ask if you can visit the children in school. It is something very special to see, the precious faces as they learn three languages, Maasai, English, and Swahili. Many will go on to college. Some will never come home, and others will return to make sure their existence and culture as a people do not cease to exist.

Can You Hear It? It's the Wild Calling

When all is said and done, if you want to have a life-changing experience and adventure, view and photograph some of the most incredible wildlife areas in the world, and experience fascinating culture and people, Tanzania should be at the top of your list. Tanzania truly offers you the "call of the wild."

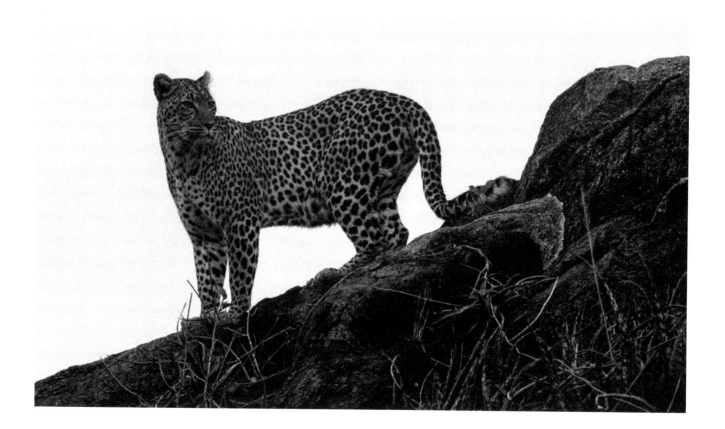

Final Thoughts—and Bon Voyage!

Thank you for taking the time to read and enjoy my third book in the *Photography Demystified* series.

Remember, when it comes to travel photography, be a traveler first and photographer second. In this way, you will not miss all the incredible aspects of the moment, which will help "feed" your inspiration and photography.

Do not forget, learn your gear before heading out, and above all—take moments to get "lost" while on your travels. Those "lost" moments seem to bring about the nuggets you may otherwise have never seen!

I personally want to invite you to get "lost" with Ally and me, as well as our awesome team, on one of our many photographic adventures around the world!

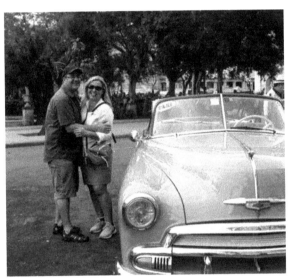

Please visit our website www.mckaylive.com where you can learn all about these amazing tours and the McKay motto of:

- Photography
- Travel
- Friendship
- Adventure!

Thank you again for reading!
—David

About the Author

David, along with his wife, Ally, owns and operates McKay Photography Academy and McKay Photography, Inc.

The academy leads tours, classes, and workshops throughout the world. Their studio is known for high-end artistic portraiture.

David is the author of *Photography Demystified—Your Guide to Creative Control and Taking Amazing Photographs*, and *Photography Demystified—Your Guide to Exploring Light and Creative Ideas*, both of which have become number one, international bestsellers helping to guide thousands of people in their pursuit of learning photography.

David holds the degrees of Master of Photography and Master of Photographic Craftsmen, as well as certification from Professional Photographer of America.

David lives in El Dorado Hills, CA, just east of Sacramento, and has been a professional photographer for over twenty-nine years.

Visit the academy website at www.mckaylive.com

Connect with the McKays

- Facebook—https://www.facebook.com/mckayphotographyacademy

- Instagram—#mckaylive

Also By David McKay

Photography Demystified—Your Guide to Gaining Creative Control
and Taking Amazing Photographs!

Photography Demystified—Your Guide to Exploring Light and Creative Ideas!
Taking You to the Next Level

Recommended Resources

www.Photorec.tv

https://www.youtube.com/user/camerarecToby

An awesome web site and YouTube channel with our friends Toby and Christina.

TONS of content and TONS of gear reviews and help!

https://www.thinktankphoto.com/pages/workshop?rfsn=141206.b44047

Best camera bags we have ever used! LOVE them!

www.photonerdsunite.com

Fantastic site with TONS of helpful content.

This site is run by our own instructors Adam and Chris

www.spiderholster.com

Great way to handle your camera! One of my favourite new items I use!

WHAT GEAR
DO YOU NEED?

Let us ship it right to your door, business or hotel!

TAKE 5% OFF
ANY RENTAL!

Use Code:
DEMYSTIFIED

www.lensprotogo.com

For all your photography gear rental needs.

If you want to become a Best Selling author . . . like I have . . .

Watch the video course: https://xe172.isrefer.com/go/firstbook/dmckay22

If I can do it, YOU CAN DO IT!

—David McKay

PS—Hundreds of people are tackling their books using this three-step, FREE video course, "From 'No Idea' to Bestseller." Join them now.

CPSIA information can be obtained
at www.ICGtesting.com
Printed in the USA
BVHW051409261218
536402BV00024B/707/P